On the Occasion of Nana & Pop's
Diamond Anniversary

Congratulations on such a
wonderful achievement
lots of love, Orla x x

Congratulations on such
a wonderful milestone and
all the best for many more.
Thank you for all the happy
memories you've given me.
Peter xxx

Congratulations on 60 happy
years and many more
ahead
Lots of love,
George
x

congrats hope
there are many many
more happy years
ahead Love Matt

Congratulations on your
anniversary, heres to
many happy years spent together
and I hope you look forward
to many more together!
Love from Alex

You're both an inspiration and
we've all learnt alot from you
both. Love Willa

Alex has left us with
precious little space!
So heres to the 70th!
Thank you for lots of
lovely memories. Ben x

DIAMONDS

A JUBILEE CELEBRATION

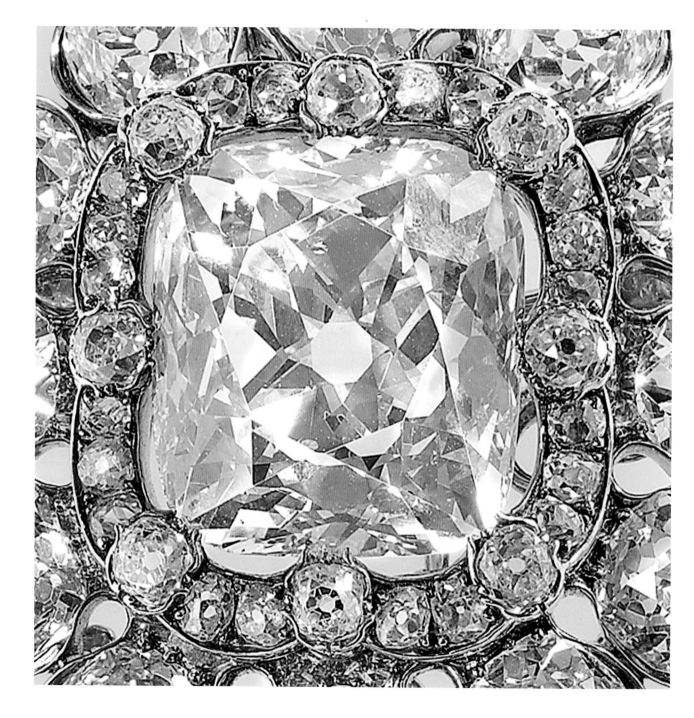

DIAMONDS

A JUBILEE CELEBRATION

Caroline de Guitaut

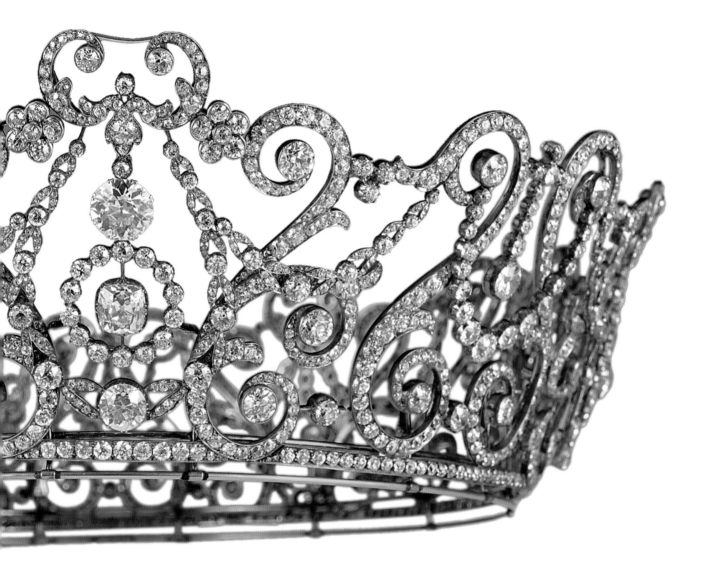

CONTENTS

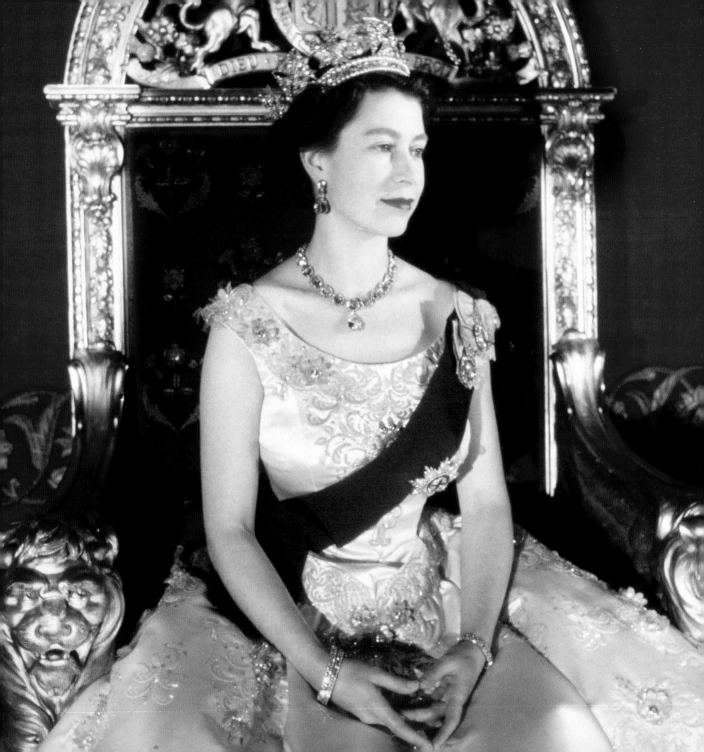

INTRODUCTION

This book accompanies an exhibition of diamonds mounted at Buckingham Palace to mark the Diamond Jubilee of Her Majesty Queen Elizabeth II. The exhibits include diamond-mounted works of art from the Royal Collection and pieces of The Queen's personal jewellery. These works span three centuries and have been selected for their significance as works of art, for the diversity of diamond cutting and mounting that they embody, and for their historic importance. They also illustrate the ways in which diamonds have been used by royal patrons and collectors. Several of the exhibits were commissioned by Queen Victoria (reigned 1837–1901), the only other British monarch to celebrate a Diamond Jubilee. These works of art are distinct from the State Regalia and jewels (Crown Jewels) held in the Tower of London.

FACING

Cecil Beaton (1904-80), *The Queen at Buckingham Palace*, 1955. Her Majesty is wearing the Diamond Diadem and the Coronation Necklace and Earrings.

Throughout history, rulers have recognised the importance of jewelled objects as symbols of magnificence, power, longevity and dynastic rule. Such objects were valuable due either to their rarity, their materials or the virtuosity with which they were made. Objects made of diamonds, the most covetable of the earth's treasures, have been valued above all else. The word 'diamond' derives from the Greek word 'adamas', meaning untamable or unconquerable 'either by fire or by blows', and is mentioned in literature as early as 300 BC. The diamond's property as the hardest substance known to man was also recognised in early literature. Pliny the Elder (AD 23–79) wrote in *Natural History* that the diamond is 'of such unspeakable hardness that when laid on the anvil it gives the blow back with such force as to shatter hammer and anvil to pieces'. If its strength equates to endurance, the purity and perfection of diamond can be seen as a symbol of the virtue of monarchy. In the early Middle Ages the diamond was a rare and highly valued object, often worn not as a decoration but as a magical amulet. Ancient myths asserted that 'he who wears a diamond will see dangers recede from him whether he be threatened by

serpents, fire, poison, sickness, thieves, flood or evil spirits'. Diamonds were point cut at this time, leaving them as close as possible to their original octahedron shape, which was believed to preserve their mythical powers.

Diamonds in the fifteenth and early sixteenth centuries were comparatively rare in Europe, but a change began to take place as more became available through the development of trade with India, the principal source of diamonds for 2,000 years. The rich Golconda fields were documented by the jeweller and traveller Jean-Baptiste Tavernier in his *Travels in India*, of 1681, but by the end of the seventeenth century they were all but exhausted. In the early eighteenth century, Brazil became the main producer of diamonds and remained so until diamonds were found in Africa. The diamond discoveries in South Africa in the late 1860s heralded a diamond rush, with tens of thousands of diggers working in the fields of the Orange Free State, and later in the Transvaal, Pretoria and Johannesburg.

After Hans Holbein the Younger, *Henry VIII*, 1538-47. Oil on panel (RCIN 404438).

DIAMONDS AND ENGLISH MONARCHS

In England, jewels supported the magnificence of the Tudor and Stuart kings, who believed that jewellery

should contribute to the aura of sovereignty. Henry VIII (1491–1547) amassed a sumptuous treasury of stones, which he frequently wore. In 1532, the recently ennobled Anne Boleyn accompanied Henry VIII to Calais, where François I gave her a valuable diamond. The 'Three Brothers' jewel was purchased by Edward VI (1537–53) and consisted of three perfectly matched spinels, open set around a huge point-cut diamond, with three pearls and a pearl drop below.

Mary I (1516–58) also owned many magnificent jewels, including a huge diamond and pearl ornament, which was returned to her husband Philip II of Spain after her death. Queen Elizabeth I (1533–1603) was rich enough to buy her own jewels and she encouraged London and continental dealers to give her first choice of their new designs. She was portrayed, almost without exception, in both painted and sculpted portraits, bejewelled from head to toe, with precious stones embroidered onto her clothes and adorning her hair. Many of these jewels were given to her by suitors including Sir Christopher Hatton and the Earl of Leicester, on her progresses around the country. Among the many jewels she purchased herself was the 'Mirror of Portugal', a 30-carat table-cut diamond valued at £5,000.

FACING:
Nicholas Hilliard (c.1547-1619), *Queen Elizabeth I*, c.1580–5, her dress, collar and hair applied with diamonds and other precious stones. Watercolour and bodycolour on vellum laid on card, actual size 5.4 × 4.5 cm. Shown here enlarged (RCIN 421029).

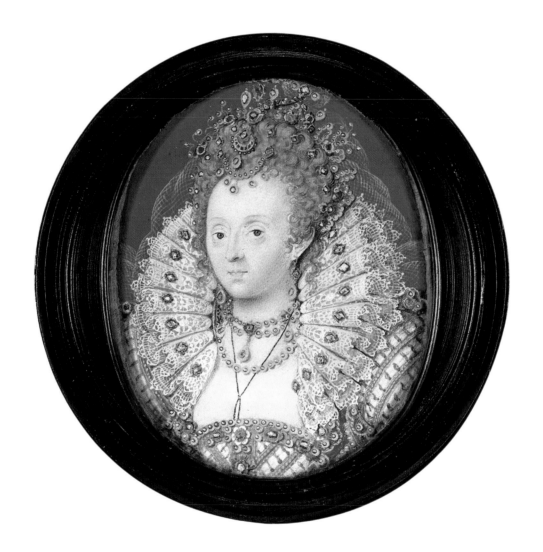

James I (1566–1625) broke up, sold and gave away quantities of Queen Elizabeth's jewels, a dispersal lamented by Sir John Eliot in a speech to Parliament in 1626: 'O! those jewels! The pride and glory of this realm! Which have made it so far shining above all others!' The King also acquired jewels, however, including the famous 55-carat Sancy diamond, bought in 1604 and which he placed in the Jewel House of the Tower of London. King James's consort, Queen Anne, bought many jewels for her personal pleasure and public prestige, and their children regularly wore diamonds and other jewels. Her daughter, Princess Elizabeth, was portrayed wearing a diamond earring and other sumptuous jewels in Robert Peake's portraits. Henry, Prince of Wales was given jewels which reflected his image as the model Renaissance prince, including one in the form of a diamond-visored helmet that he wore in his cap as a sign of his military prowess. His brother, the future Charles I (1600–49), also began wearing jewels at an early age, including the 'Three Brothers' brooch.

In the pre-Civil War court, jewellery-making was particularly encouraged as diamonds became more available, the result of increased trade with India. Changing fashions in court dress, with lighter and more fluid garments

Henry Pierce Bone (1779-1855), *Anne of Denmark*, 1837. Enamel on copper (RCIN 422349).

and *décolletés* fostered changes in the style of jewellery. The lighter fabrics could not support rows of rosettes and heavy encrustations of jewels, the weight of which had often made it impossible for the wearer to move easily; as a result, parures with symmetrical designs became fashionable and coloured stones gave way to the brilliance of diamonds, particularly since the rose cut had started to replace table-cut stones. With the Restoration of the Monarchy in 1660 came a resurgence of jewellery-making and the fashion in women's dress for square-cut, low décolleté encouraged the wearing of diamond necklaces and pendants.

Among other innovations at this period, the practice of taking snuff became fashionable across Europe towards the end of the seventeenth century, and by about 1680 jewellers began to make gold snuffboxes. The design and embellishment of such boxes with gemstones became ever more luxurious; those produced for Frederick the Great of Prussia were among the most sumptuous ever made and include a magnificent diamond-encrusted box now in the Royal Collection (page 60).

George II (1683–1760) and George III (1738–1820) understood the symbolic value of jewels for themselves and their consorts. On ceremonial occasions, George II

dressed splendidly, with diamond hat and coat buttons, in addition to his Garter Star and Great and Lesser Georges. In 1745, he sent valuable jewels to Hanover for safekeeping; these were later bequeathed to George III. George III's consort, Queen Charlotte (1744–1818), was the first British queen since the early seventeenth century to possess jewels rivalling those of Continental royalty, and this shift mirrored the changing fashion for female as opposed to male jewellery. In addition to the Hanoverian jewels, Queen Charlotte received many jewels as presents, including diamonds from both the Mughal Emperor Shah Alam and the Nawab of Arcot.

George IV (1762–1830) had a life-long passion for jewels and his prodigious expenditure on them added to his huge debts. For part of his coronation ceremony in 1821, he wore the magnificent Diamond Diadem (page 108), which he commissioned from the royal goldsmiths and jewellers, Rundell, Bridge & Rundell, and for which the diamonds were rented. Not all the jewelled items he purchased were newly made: a mid-eighteenth-century German small sword that he acquired – of a type that had become an indispensable part of a gentleman's court dress – was remodelled and applied with hundreds of diamonds (page 104).

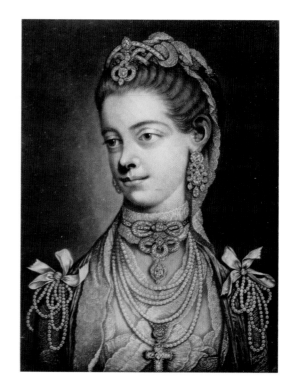

Thomas Frye (*c.*1710-62), *Queen Charlotte*, 1762. Mezzotint (RCIN 604595).

Sir George Hayter (1792–1871),
Queen Victoria, 1840. Oil on canvas
(RCIN 405185).

During the long reign of Queen Victoria (1819–1901, reigned from 1837), jewellery played a highly significant role. Personal jewels given by Prince Albert (1819–61) marked almost every significant event in their life together, while jewels worn on public occasions enabled her to enhance the majesty of her appearance in the same way as her predecessors had done. The majority of the most significant commissions were placed with the then Crown Jeweller, Garrard, including the magnificent Coronation Necklace and Earrings (pages 28, 32). Other jewels were received as gifts from foreign rulers, including from the Sultan of Turkey (page 34). In 1850, the Queen was presented with one of the most famous diamonds in the world, the Koh-i-nûr, which had come from the Treasury of Lahore and now is set into the crown of Queen Elizabeth The Queen Mother, kept in the Tower of London.

During the reign of King Edward VII (1841–1910, reigned from 1901), the Cullinan Diamond – the largest diamond ever found – was presented to the King (page 64). However, it was not until the reign of King George V (1865–1936, reigned from 1910) that the majority of the stones cut from the Cullinan were mounted – some

FACING:
W & D Downey, *Queen Mary, The House of Lords*, 6 Feb 1911. Gelatin silver print. Queen Mary is wearing Cullinan I and II on her garter riband and III and IV attached to the Coronation Necklace (RCIN 2808304).

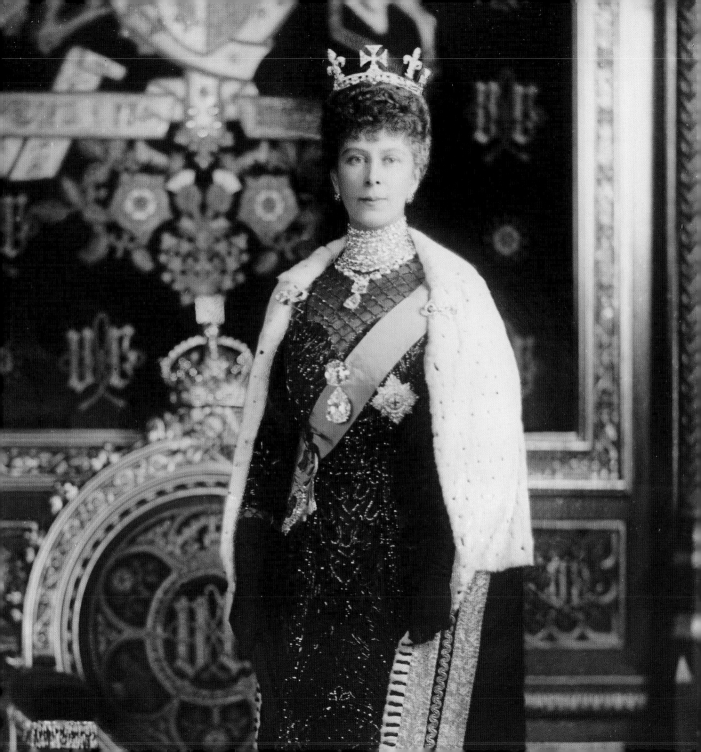

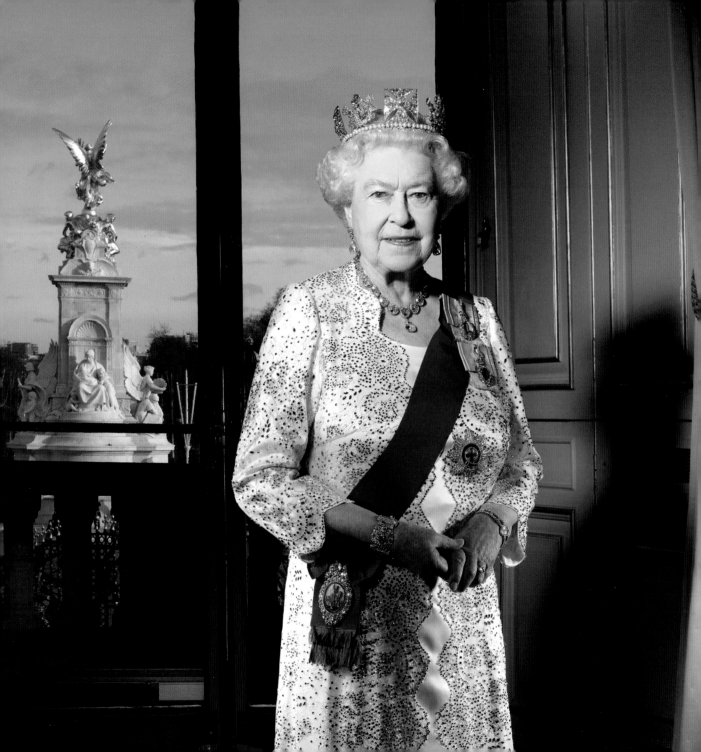

into the Crown Jewels and others into personal jewellery made for Queen Mary (1867–1953). A connoisseur of jewellery and works of art, Queen Mary acquired many diamond jewels, including the Girls of Great Britain and Ireland Tiara, which she received as a wedding present in 1893 (page 46) and the Delhi Durbar Tiara made in 1911 (page 52).

In the reign of Queen Elizabeth II (b. 1926) the diamond jewels and diamond-set works of art acquired by her predecessors continue to play an important role. The Queen's jewellery also includes a number of pieces marking important occasions in her own life – such as the diamond necklace given on the occasion of her 21st birthday (page 96) and the magnificent pink diamond, presented on the occasion of her marriage to Prince Philip, both in 1947 (page 100).

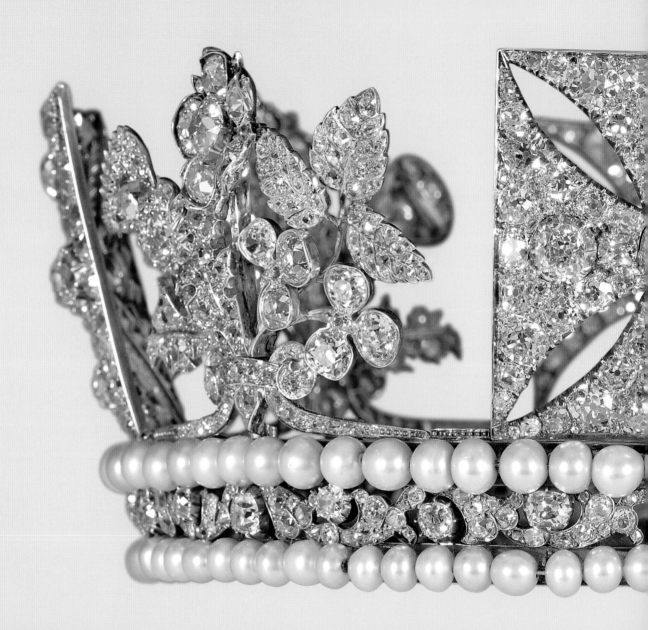

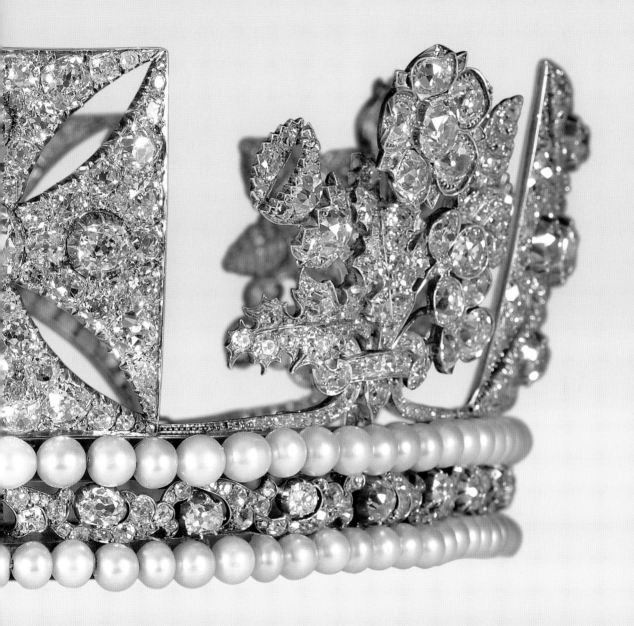

QUEEN VICTORIA'S SMALL DIAMOND CROWN

1870

This diminutive crown, which measures no more than 10 cm in diameter, was supplied by R. & S. Garrard and Co. in March 1870. The crown became the most recognisable jewel of Queen Victoria's middle and old age and she was regularly depicted wearing it in paintings, sculptures, on coins and in photographs, notably her official portrait by W. & D. Downey, taken in 1893 and released to mark her Diamond Jubilee on 22 June 1897.

It consists of a silver openwork frame, laminated with gold and set with 1,187 brilliant, rose and mixed-cut diamonds and some diamond chips. The stones were probably taken from a fringe-pattern *chaîne de corsage* and may include diamonds presented to Queen Victoria in May 1856 by the Sultan of Turkey, Abdul Mejíd I (1823–61), in gratitude for Britain's support during the Crimean War. The *chaîne*

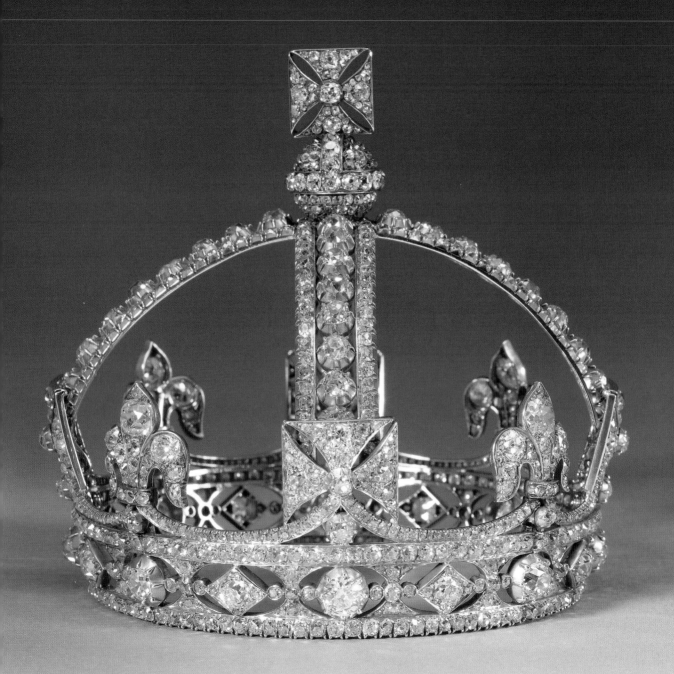

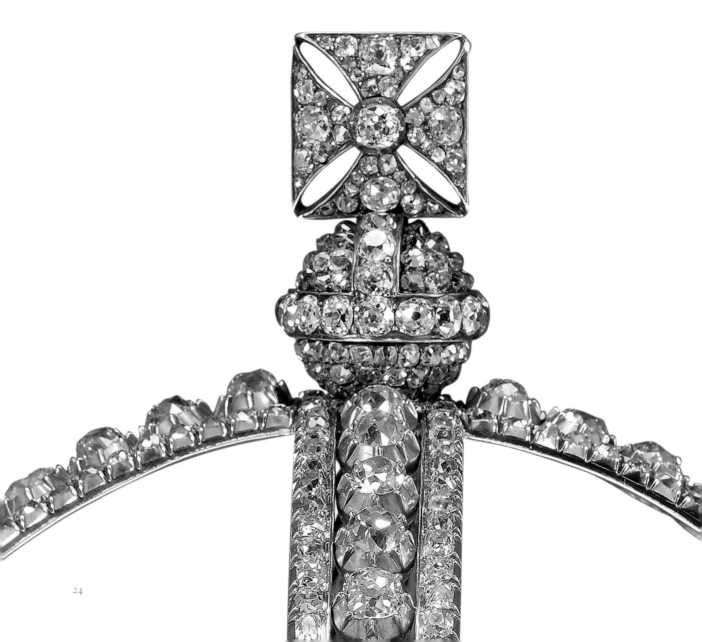

FACING:
Detail of monde and cross
on Queen Victoria's Small
Diamond Crown.

de corsage is clearly visible in F.X. Winterhalter's state portrait of 1859 (page 31).

In form it is reminiscent of a traditional English crown, in particular Queen Mary of Modena's State Crown, made in 1685, with which it shares the conventional crest of four convex crosses-paty and four fleur-de-lis rising from a diamond-set band. The arches are surmounted by a monde and cross. It is also similar to Queen Charlotte's Nuptial Crown, which Queen Victoria had worn earlier in her reign, but which was returned to Hanover in 1858 (see page 30). The Small Diamond Crown could be worn as a circlet with the arches removed. This added to the lightness of the jewel, which, even with its arches, weighs no more than 140 grams.

Following Prince Albert's untimely death on 14 December 1861, the Queen withdrew from public engagements for a long period. For the remainder of her life she wore mourning clothes,

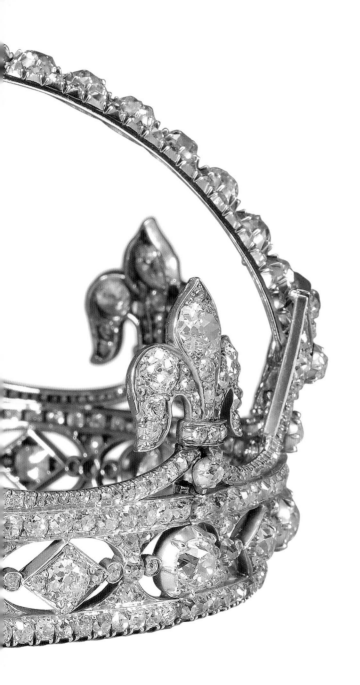

FACING:
Queen Victoria's Diamond Jubilee Portrait,
photographed by W & D Downey in 1893
for release in 1897. The Queen wears the Small
Diamond Crown minus its arches (RCIN 31705).

with which she found it impossible to wear her coloured jewels that were so closely associated with happier times. The commissioning of the Small Diamond Crown satisfied the need for a formal head ornament of colourless stones, suitable for mourning and usually worn over a veil of Honiton lace. The Queen recorded the first wearing of the crown in her Journal on 9 February 1871 at the State Opening of Parliament: 'Wore a dress trimmed with ermine & my new small diamond crown over a veil, on my head'.

The crown was placed on the Queen's coffin at Osborne before her body was conveyed to London for the state funeral in February 1901. It was subsequently worn by Queen Alexandra, who then relinquished it to Queen Mary. In 1937, King George VI added it to the display at the Tower of London, where it has remained ever since.

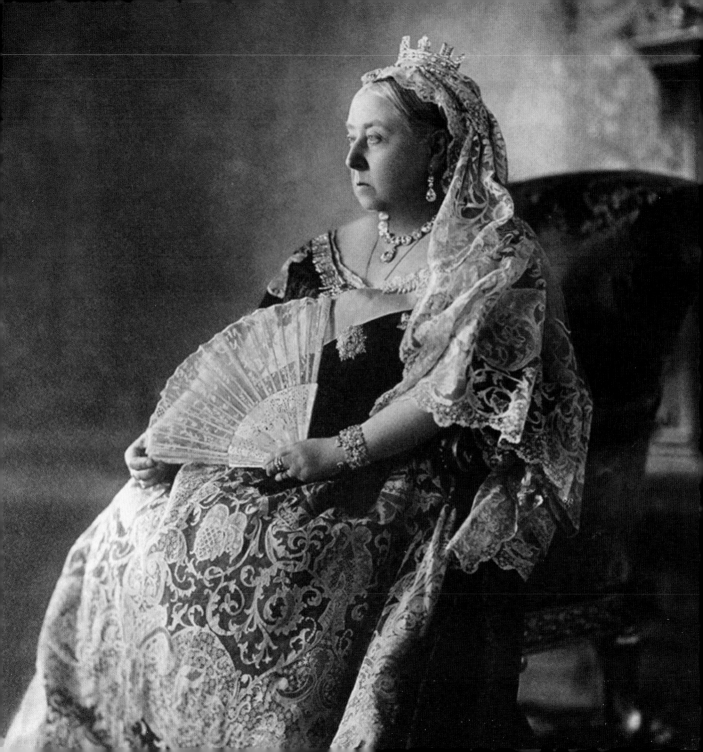

THE CORONATION NECKLACE

1858

This magnificent necklace was made for Queen Victoria by R. & S. Garrard & Co. in 1858. It has acquired its name from having been worn at the coronations of Queen Alexandra in 1901, Queen Mary in 1911, Queen Elizabeth in 1937 and Her Majesty The Queen in 1953. Like almost all inherited royal jewellery, it has undergone complicated changes since it was originally made. It now consists of 25 graduated cushion-cut brilliant diamonds set in silver with gold links, and a large pendant diamond of 22.48 metric carats, known as the Lahore Diamond.

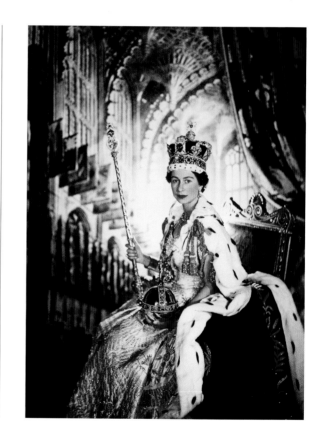

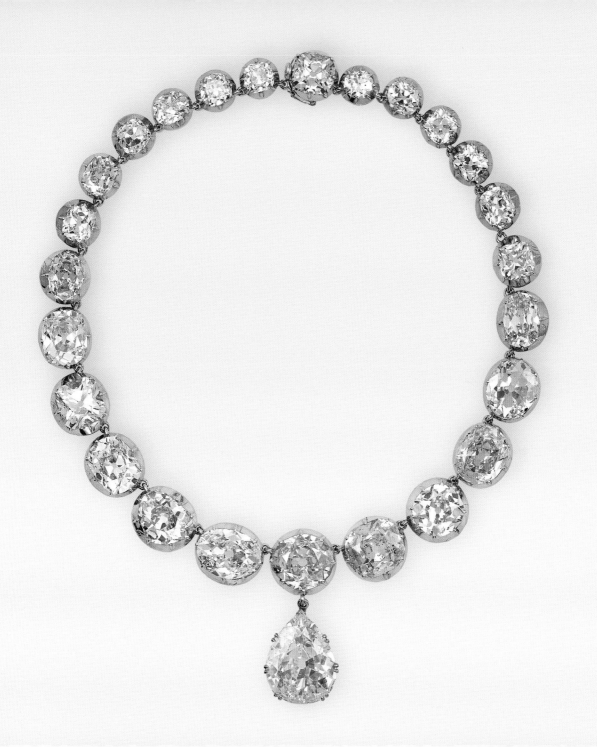

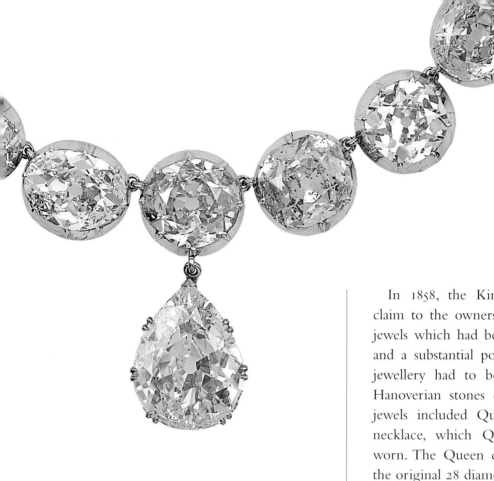

Detail of the
Lahore Diamond Pendant.

In 1858, the King of Hanover won the claim to the ownership of Queen Charlotte's jewels which had been initiated by his father, and a substantial portion of Queen Victoria's jewellery had to be dismantled so that the Hanoverian stones could be returned. These jewels included Queen Charlotte's diamond necklace, which Queen Victoria had often worn. The Queen decided to replace it, and the original 28 diamonds for the new necklace, the largest of which weigh between 8.25 and 11.25 metric carats, were taken from a Garter Badge and a jewelled sword hilt. Queen Victoria regularly wore this necklace and it is often seen in portraits, notably in F.X. Winterhalter's state portrait of 1859. It was first altered in 1911, when two stones were removed to make solitaire ear-

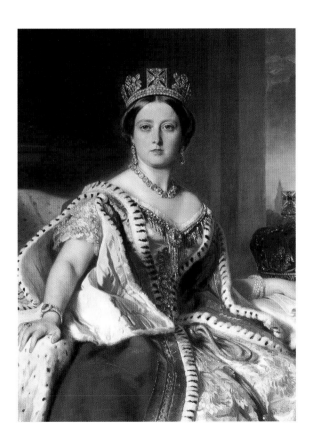

rings for Queen Mary and were replaced with three other stones. For the 1937 coronation, the Lahore Diamond pendant was slightly re-cut and temporarily set in Queen Elizabeth's new crown, but was afterwards returned to the necklace. Her Majesty The Queen had the necklace reduced by four stones before wearing it to her own coronation in 1953.

F.X. Winterhalter (1805–73), *Queen Victoria*, 1859 (detail). Oil on canvas (RCIN 405131).

THE CORONATION EARRINGS

Like the Coronation Necklace, these diamond drop earrings were worn at the successive coronations of Queen Mary, Queen Elizabeth and Her Majesty The Queen. The earrings were made by R. & S. Garrard & Co. in 1858 for Queen Victoria and consist of four cushion-cut collet-set diamonds, taken from an existing aigrette and Garter Star, and two drop-shaped pendants (of approximately 12 and 7 carats). The drop pendants were originally set as the side stones of the Indian armlet setting of the Koh-i-nûr.

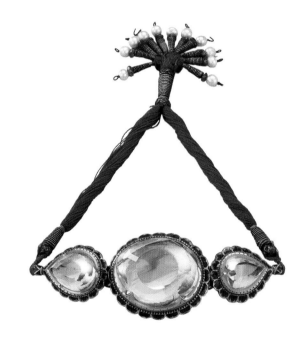

RIGHT:
Indian (?Jaipur), the Koh-i-nûr armlet setting,
c. 1830. Gold, enamel, rock crystal,
glass, rubies, pearls and silk.

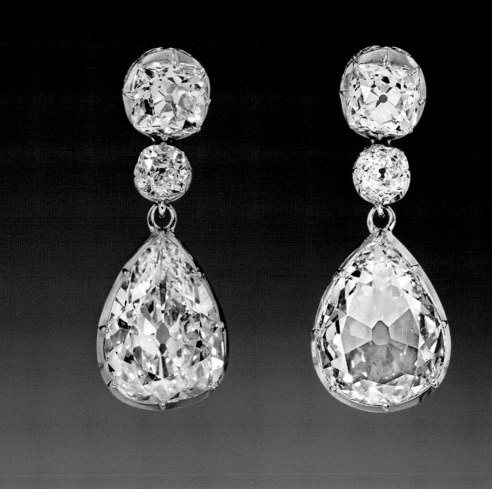

QUEEN VICTORIA'S FRINGE BROOCH

1856

This brooch appears originally to have formed the centre of a fringe-pattern *chaîne de corsage*, made by R. & S. Garrard & Co. for Queen Victoria in 1856. The larger stones are thought to have come from one of the two impressive jewels presented to the Queen earlier in 1856 by the Sultan of Turkey, one of which, according to her Journal of 8 May 1856, she decided she could not wear and wished to have reset.

The *chaîne de corsage*, which cost £450 10s to make, does not appear to have been worn after Prince Albert's death in 1861, and when the Queen decided to order her Small Diamond Crown (page 22) in 1870, the fringe elements

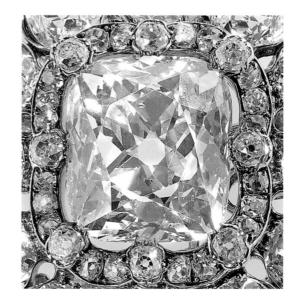

RIGHT:
Detail of the central stone in
Queen Victoria's Fringe Brooch.

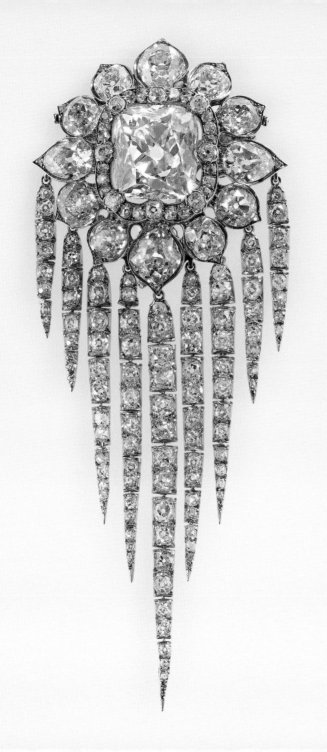

were probably sacrificed to provide the stones for it. The brooch is of typically mid-nineteenth-century style and now consists of a large emerald-cut central stone, which, with the immediately surrounding small brilliant-cut diamonds, is detachable as a separate brooch. Nine graduated pavé-set chains are suspended from the outer row of 12 large brilliant-cut diamonds.

Queen Victoria left the brooch to King Edward VII. Queen Alexandra, Queen Mary and Queen Elizabeth all wore it regularly, and in 2002 it passed to Her Majesty The Queen.

FACING:
The Queen wearing the Fringe Brooch together with the Girls of Great Britain and Ireland Tiara, the Coronation Necklace and the Greville Peardrop earrings, at the State Banquet held at Buckingham Palace for the visiting President of Turkey, Abdullah Gül (left), and his wife Hayrunnisa (right), November 2011.

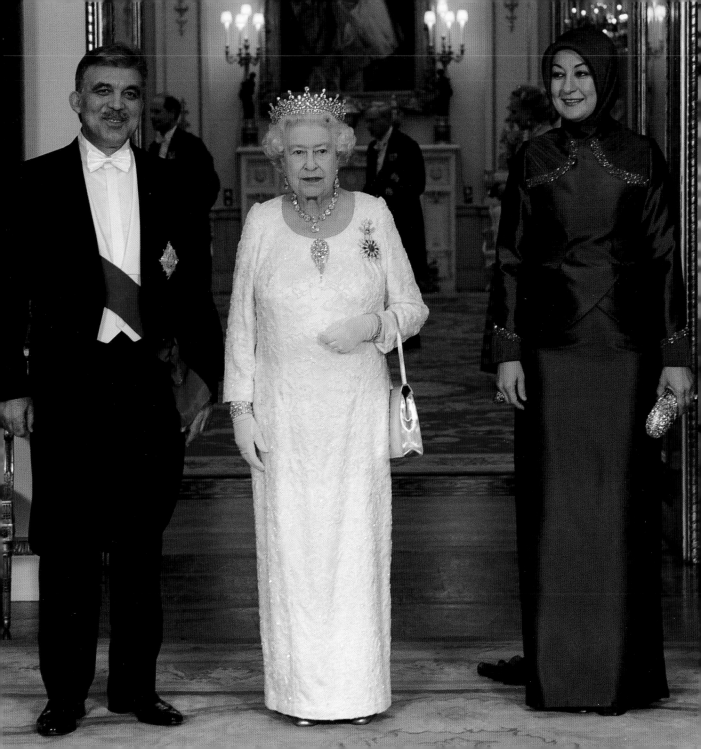

QUEEN ALEXANDRA'S KOKOSHNIK TIARA

1888

The kokoshnik is a traditional Russian folk headdress, which takes the form of a stiff halo covered with textile to which sparkling ornaments are applied. It was adopted by the imperial family in the nineteenth century for nationalistic reasons and used as the inspiration for the new style of sumptuous heavily jewelled tiaras worn at court from the mid-century onwards. The significance of the family ties between the Russian and British royal families ensured that the Russian style was keenly adopted in the West, where the kokoshnik tiara

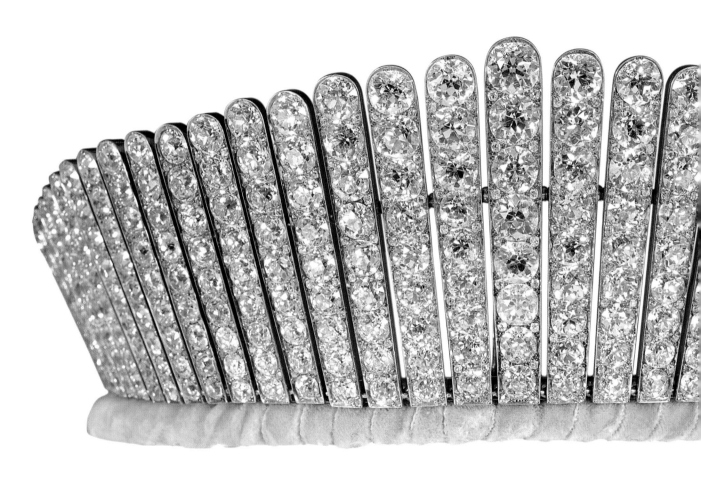

became fashionable in the late nineteenth and early twentieth centuries.

This example was made for Alexandra, Princess of Wales, sister of Empress Maria Feodorovna, consort of Tsar Alexander III of Russia. It was presented for her 25th wedding anniversary in 1888 by the 'Ladies of Society' (365 peeresses of the United Kingdom), and was made by R. & S. Garrard & Co. at a cost of £4,400. Each bar is pavé-set with brilliant-cut diamonds, set in white and yellow gold. The perfect matching of the stones in the bars required great skill by the jeweller. Like tiaras of a similar design, it could also be worn as a necklace. Queen Alexandra wore it on many occasions, notably for the marriage of the Duke of York (later King George V) to Princess Victoria Mary of Teck in 1893. Queen Mary inherited the tiara and wore it frequently. It was bequeathed to The Queen in 1953.

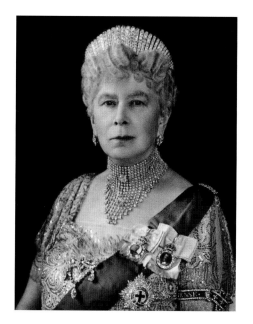

Queen Mary photographed in 1947 wearing the Kokoshnik Tiara.

FACING:
The Queen wearing the Kokoshnik Tiara in Jamaica in 2002.

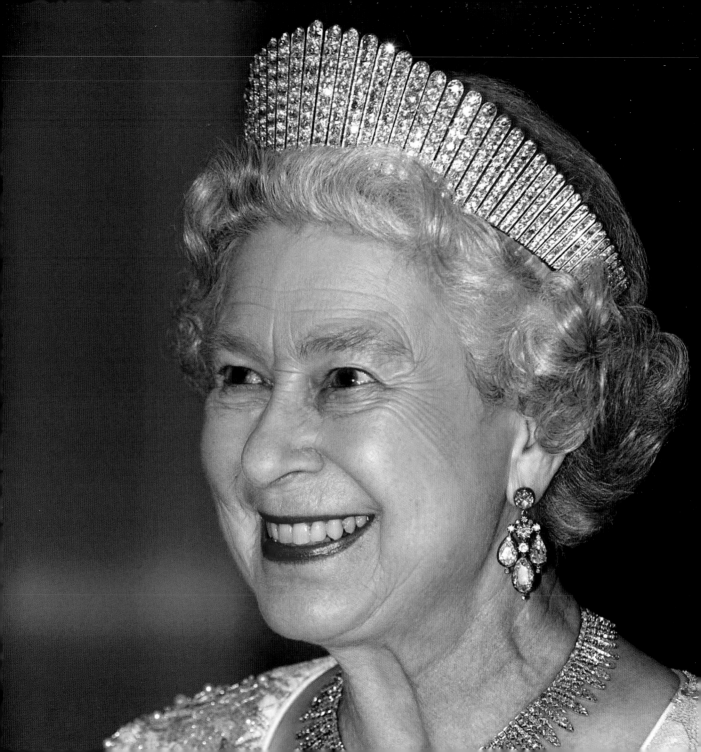

QUEEN ALEXANDRA'S CORONATION FAN

*c.*1902

This magnificent fan was made for Queen Alexandra at the time of the coronation in 1902. The tortoiseshell guards of the fan are elaborately set with brilliant and rose-cut diamonds. The front guard incorporates a design of trailing flowers and foliage set in silver, terminating in a diamond head and silver loop set with brilliant diamonds. The back guard is set with a crowned 'A' cipher, also in diamonds.

Fans incorporating ostrich feathers are re- corded from as early as the sixteenth century. Elizabeth I is seen holding a gold and gem-set fan with exotic feathers in a portrait painted *c.*1592, at Hardwick Hall. The ostrich feathers were mainly sourced in Venice, which was the principal point of entry for them in Europe. The fashion for folding fans incorporating ostrich feathers evolved in the second half of the nineteenth century, and in this example the

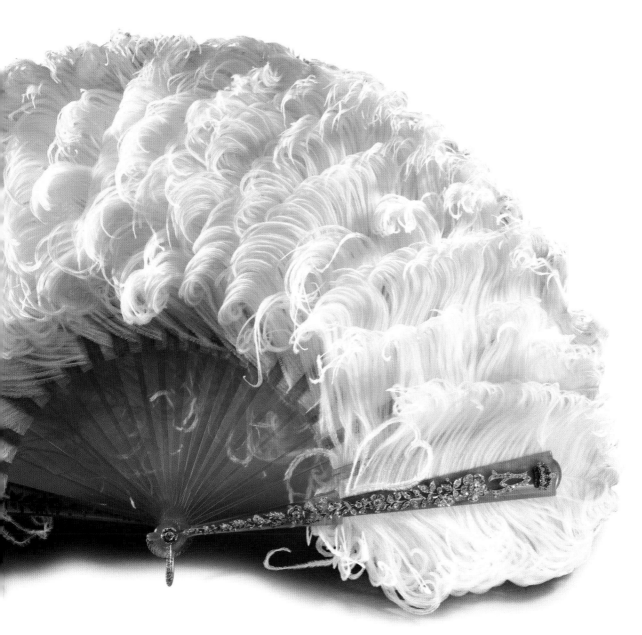

FACING:
Detail of Queen Alexandra's diamond
cipher, the crown also set with rubies.

feathers have been artificially curled by softening the shaft of each feather in a steamy atmosphere and then scraping it until it curls.

Queen Alexandra acquired a large number of fans during her lifetime; many were gifts from her family and most passed to her daughter-in-law, Queen Mary, who was an enthusiastic collector. Queen Mary gave this diamond-encrusted fan to Queen Elizabeth at a family lunch at Buckingham Palace, two days before the coronation of King George VI in May 1937.

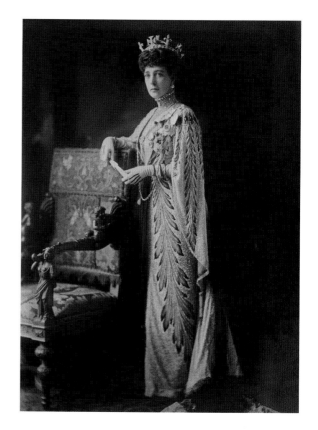

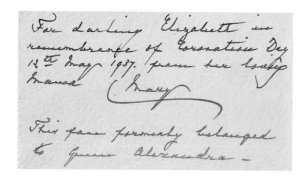

Label in Queen Mary's handwriting recording her presentation of the fan to Queen Elizabeth, May 1937.

W. & D. Downey, *Queen Alexandra*, 1913, (RCIN 2106376).

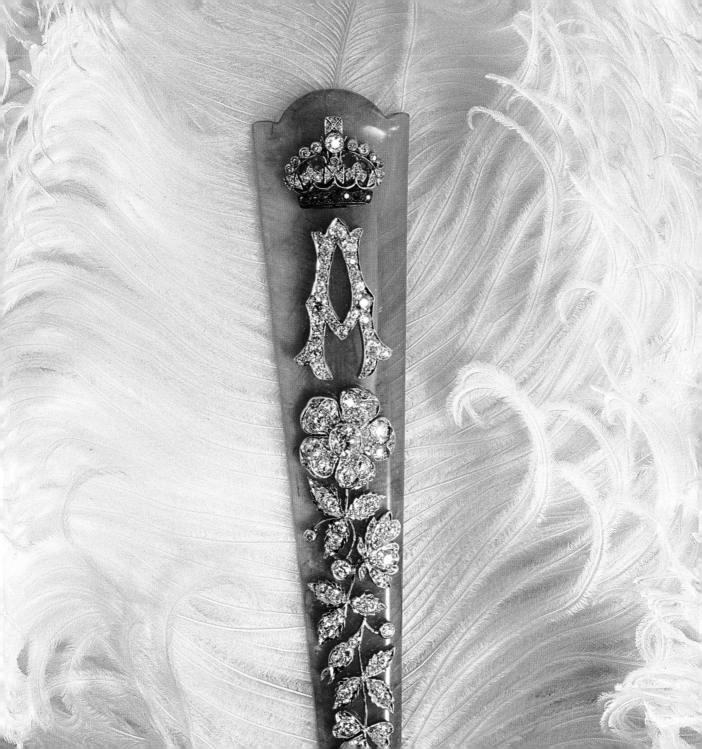

QUEEN MARY'S GIRLS OF GREAT BRITAIN AND IRELAND TIARA

1893

This tiara was a present to Princess Victoria Mary of Teck from the 'Girls of Great Britain and Ireland' on the occasion of her marriage to the Duke of York, later King George V, in May 1893. It was supplied by R. & S. Garrard & Co. and purchased with money raised by a committee chaired by Lady Eva Greville. The tiara is of scrolled and pierced foliate form, with the diamonds pavé-set in silver and gold.

The original entry in Garrard's Royal Ledger shows that it was originally surmounted by 14 large oriental pearls. The tiara could also be

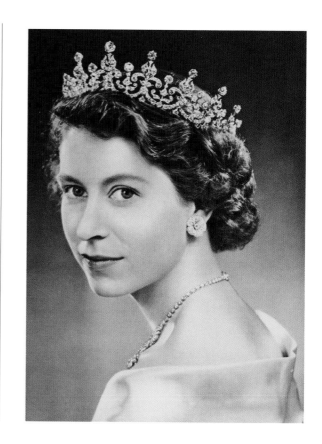

RIGHT:
The Queen wearing the
Girls of Great Britain and Ireland Tiara,
photographed by Otto Benjamin
(1903–98) in the 1950s.

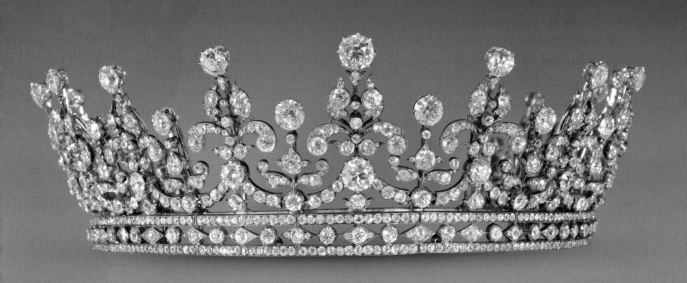

worn as a necklace or even, when dismantled and mounted on a smaller frame, as a coronet, in which form Queen Mary wore it for the Devonshire House Ball in 1897 (see page 51).

In 1914, Queen Mary adapted the tiara to take 13 brilliant-cut diamonds in place of the pearls. Probably around the same time, the lozenge-pattern bandeau from the base was removed, enabling it to be worn separately as a headband, to suit the fashion of the time. For Princess Elizabeth's wedding in November 1947, Queen Mary gave her granddaughter the tiara and the bandeau, which were reunited in 1969. Over the years this tiara has become one of the most familiar of Her Majesty's tiaras through its appearance on banknotes and coinage.

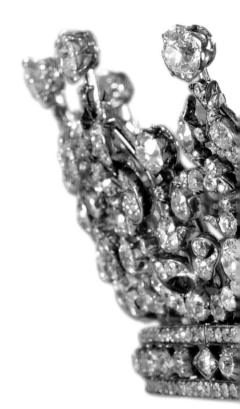

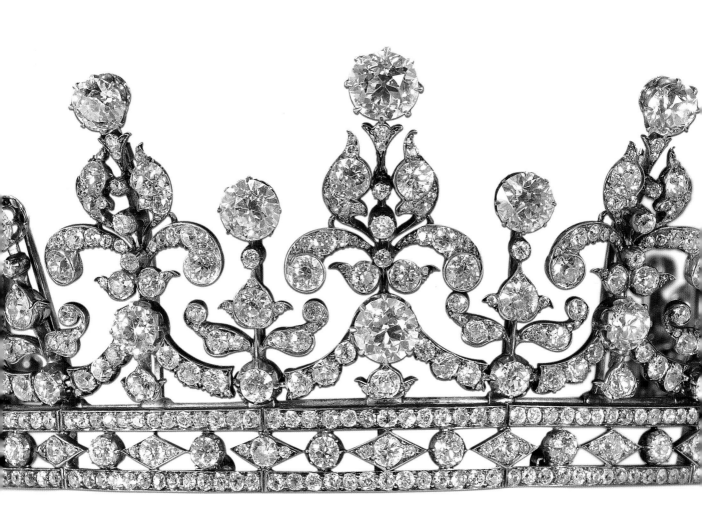

Each Bank of England note features The Queen
wearing the Girls of Great Britain and Ireland Tiara.

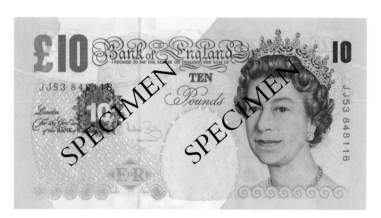

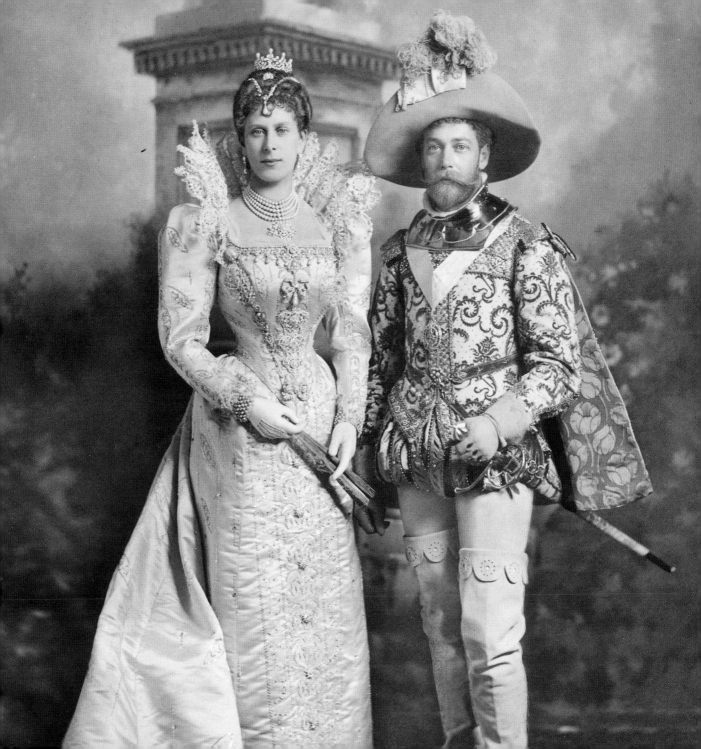

THE DELHI DURBAR TIARA

1911

This tiara was made in 1911 for Queen Mary to wear to the Durbar (a 'ceremonial gathering to pay homage') in Delhi on 12 December 1911, to mark the succession of King George V as King Emperor. The tiara was part of the Queen's parure of emeralds and diamonds made for the occasion by Garrard & Co. Ltd. The parure included a necklace (page 82), stomacher, brooch and earrings. King George V, who wore the Imperial Crown of India (specially made for the occasion and now part of the display in the Tower of London) referred to the Delhi Durbar Tiara as 'May's best tiara'.

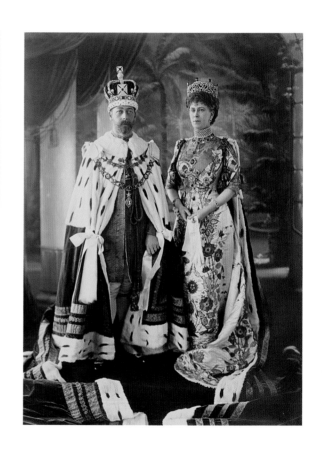

RIGHT:
King George V and Queen Mary, the Delhi Durbar portrait, 1911. Queen Mary wears the emerald and diamond parure including the Delhi Durbar Tiara (RCIN 2917139).

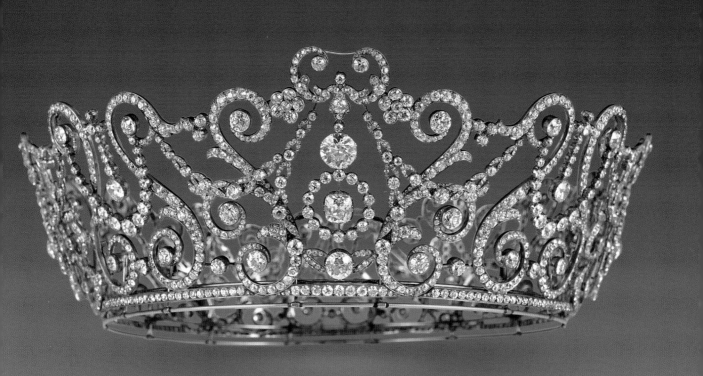

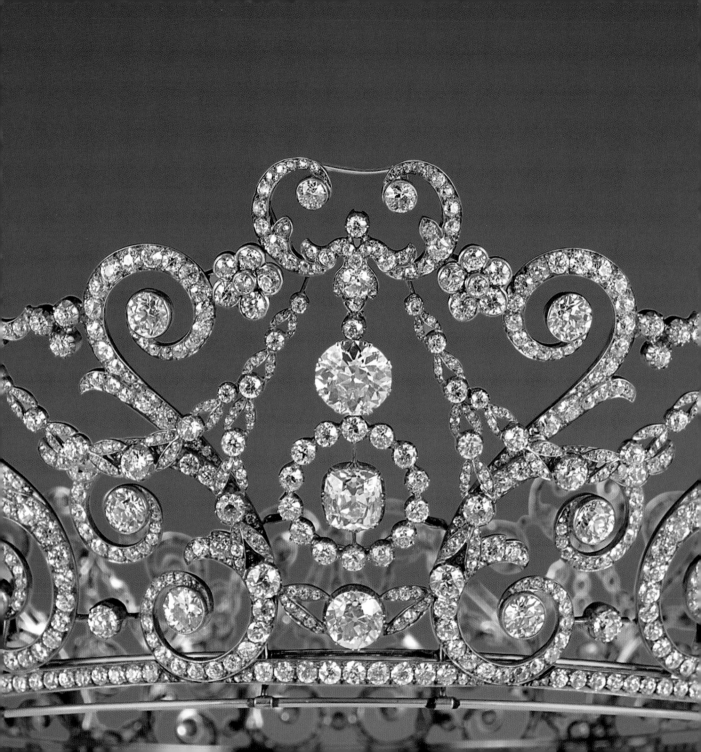

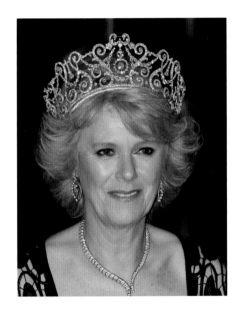

The Duchess of Cornwall wearing the
Delhi Durbar Tiara at a state banquet for
Queen Sonja and King Harold V of Norway.
Buckingham Palace, October 25 2005.

FACING:
Detail of the
Delhi Durbar Tiara.

The tiara takes the form of a tall circlet of lyres and S-scrolls, linked by festoons of rose and brilliant-cut diamonds. The upper border was originally set with ten of the Cambridge emeralds, acquired by Queen Mary in 1910 and originally owned by her grandmother the Duchess of Cambridge, but these were removed by 1922 for use elsewhere.

In the year following the Delhi Durbar, the tiara was altered to take either or both of the two Lesser Stars of Africa – Cullinan III and IV (page 72); the drop-shaped stone was held at the top of the jewel and the cushion-shaped stone hung in the oval aperture below. Queen Mary loaned the tiara to Queen Elizabeth in 1946 for the South African Tour in 1947, and it remained with her until her death in 2002. In 2005, it was loaned by The Queen to The Duchess of Cornwall.

JAIPUR SWORD AND SCABBARD

1902

This extraordinarily richly decorated sword and
scabbard, set with 719 diamonds, was presented
to King Edward VII on the occasion of his
coronation in 1902 by the Maharajah of Jaipur
Sawai Sir Madho Singh Bahadur (1861–1922).
Edward VII, when Prince of Wales, had visited
Jaipur during his Indian Tour of 1875–6 and had
laid the foundations of the Albert Hall in Jaipur.
The Maharajah was among a large number
of foreign heads of state who had travelled to
England to pay homage to the new King, but at
the last moment the coronation, which was to
have taken place in June, had to be postponed
due to the King's appendicitis. The coronation
eventually took place on 9 August, and in the
meantime the Maharajah remained in England
with some of his retinue of 400 staff, notably his
cook and his jeweller.

The sword hilt and the scabbard are of gold,
enamelled in blue, green and red and set with

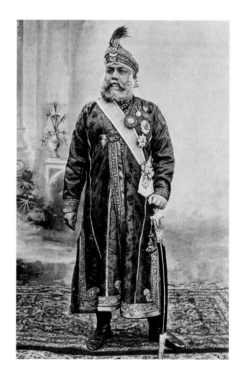

The Maharajah of Jaipur Sawai Sir Madho
Singh Bahadur, photographed in 1911
(RCIN 1054623).

56

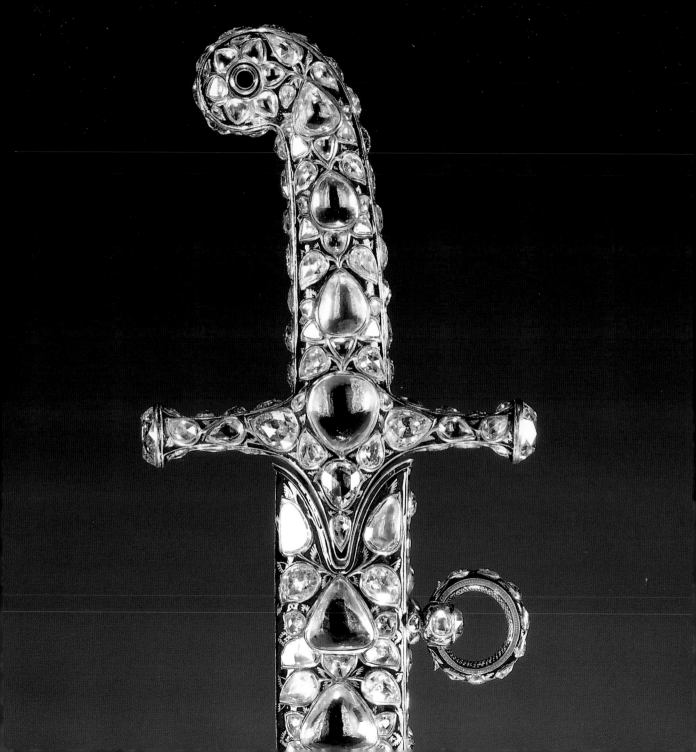

A TOKEN OF THE LOYALTY OF
SAWAI MADHO SINGH,
MAHARAJAH OF JAIPUR.
9TH AUGUST, 1902.

rose-cut, brilliant-cut and Indian lasque stones (flat, unfaceted diamonds), which vary in colour from white to yellow and are set in a stylised design of lotus flowers and leaves. The flat cut of many of the stones, combined with their silver-backed settings, is typical of Indian jewellery. The rose and brilliant-cut stones were possibly cut in Europe and are an example of the centuries-old trade in diamonds between India and Europe. In total, the weight of the stones in the sword and scabbard is in the region of 2,000 carats, with the largest stones thought to be the pale yellow diamonds in the end of the cross-guard, one of which is estimated at 36 carats.

The steel blade was evidently inscribed in England.

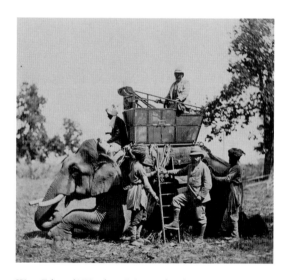

King Edward VII when Prince of Wales, photographed in India during the Royal Tour of 1875–6. The Prince is about to ascend the ladder onto the elephant (RCIN 2701993).

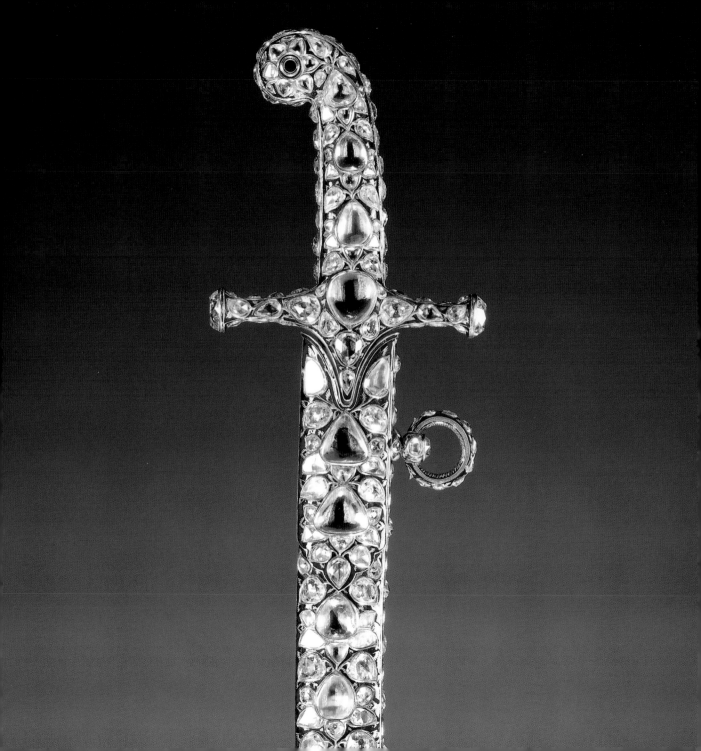

TABLE SNUFF BOX OF FREDERICK THE GREAT OF PRUSSIA

*c.*1770

The ingenuity of the pictorial setting of the diamonds on this bloodstone snuff box contributes to its spectacularly lavish design. It is encrusted with almost three thousand diamonds, backed with delicately coloured foils in shades of pink and yellow on each of its six sides; the diamonds almost completely obscure the sumptuous cartouche-shaped bloodstone box beneath. The stones are rose and brilliant-cut and set in a combination of silver and gold rub-over settings in designs of flowers, foliage, musical trophies, insects and ribbons. The chased mounts, in vari-coloured gold, add to the flamboyance of the box.

This box is one of the finest of a series made in the Fabrique Royale in Berlin, many of the same distinctive shape, for Frederick II of Prussia (1712–86), known as Frederick the Great, and for his court. Frederick was a moderniser and a great patron of the arts. Musicians, philosophers

Antoine Pesne (1683–1757), *Frederick II, King of Prussia*, *c.*1736. Oil on canvas (RCIN 406797).

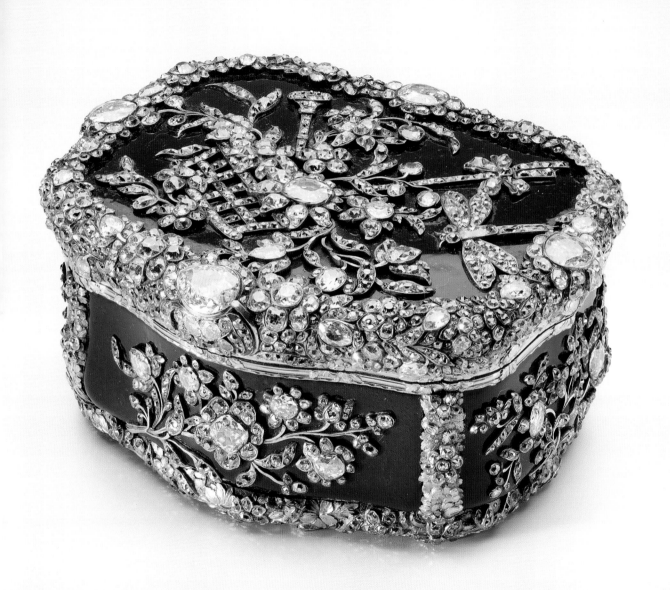

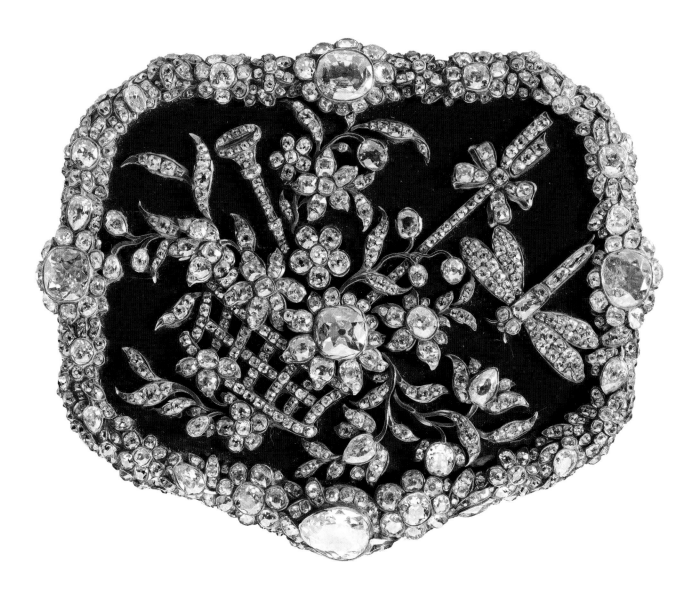

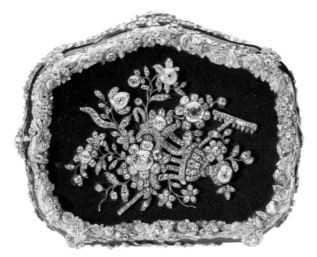

and artists flocked to the Prussian Court. The identity of the maker of this box is difficult to determine due to the absence of hallmarks. Among the most frequent suppliers to the Prussian court were André and Jean-Louis Jordan and Daniel Baudesson, together with the designer Jean Guillaume George Krüger.

This box is thought to have been inherited by Frederick William III of Prussia and given to his daughter, Tsarina Alexandra Feodorovna, consort of Tsar Nicholas I, who passed it to her descendants. It was listed in the 1922 inventory of personal belongings of the imperial family confiscated by the Soviet authorities in 1917. It subsequently came to England and was sold twice through Christie's before being purchased by Queen Mary in 1932.

THE CULLINAN
DIAMOND

The celebrated Cullinan Diamond is the largest ever found. It weighed 3,106 metric carats in its rough state and was discovered at the Premier Mine near Pretoria in South Africa on 26 January 1905. It was named after the chairman of the mining company, Thomas Cullinan. At first the stone was thought to be a crystal, but once it had been confirmed as a diamond, Cullinan had 12 replicas of it made in glass (three are in the Royal Collection), one for himself and one each for the 11 guests with whom he had been dining when news of the discovery of the stone reached him.

In addition to its remarkable size (10.1 × 6.35 × 5.9 cm), the Cullinan was notable for its extraordinary blue-white colour and exceptional purity. The stone in its rough form possessed a cleavage face on one side, which suggested that it might once have formed part of an even larger stone. After being put

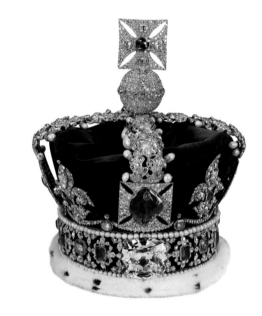

ABOVE:
The Imperial State Crown, made for King George VI by Garrard & Co, 1937.

FACING:
Detail of the Imperial State Crown, showing Cullinan II, the Second Star of Africa.

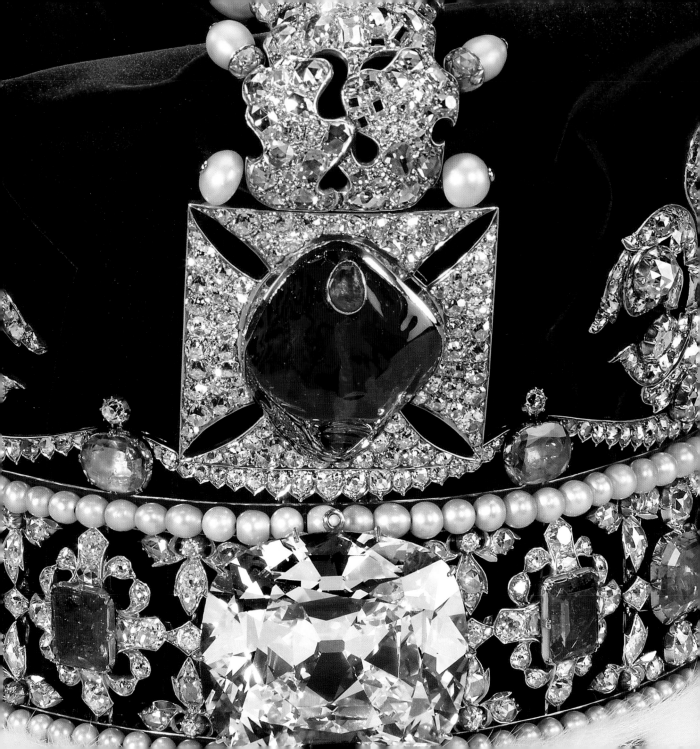

on display at the offices of the Standard Bank in Johannesburg, the diamond was sent to London, where it was taken to Buckingham Palace for inspection by King Edward VII. For the next two years the stone remained a public wonder, during which time it was shown to many prospective purchasers. Eventually, the Prime Minister of the Transvaal, General Louis Botha (1862–1919), suggested that his government should acquire the Cullinan and present it to King Edward as a token of loyalty. At first the British Government was hesitant about the proposal, but the King was subsequently encouraged to accept the gift.

On 9 November 1907, under close police protection, the stone was duly conveyed to Sandringham House in Norfolk, where the King was celebrating his 66th birthday. It was formally presented by Sir Francis Hopwood, the Under-Secretary of State for the Colonies. The gift did not include the cost of cutting the stone,

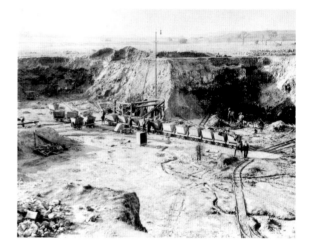

The Premier Mine near Pretoria, South Africa, where the Cullinan Diamond was discovered.

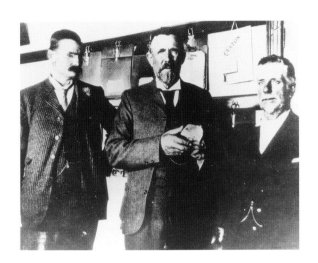

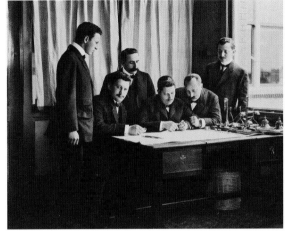

William McHardy, Thomas Cullinan and Fred
Wells holding the uncut Cullinan on the day the
stone was found, 26 January 1905, (left),
and Joseph Asscher with members
of his firm examining the
Cullinan Diamond (right).

and after consultation with the firm of M.J.
Levy and Nephews of Holborn, it was decided
to entrust the cutting to the celebrated firm of
I.J. Asscher of Amsterdam. Three members of
the Asscher family travelled to London and took
the diamond back to Amsterdam.

The complexities of cutting such a huge stone
were many, for it could not be cut into a single

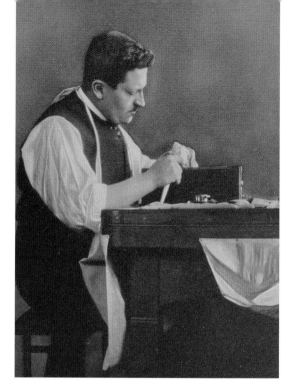

gem and cleaving or sawing would therefore be necessary. It was thought inadvisable to use a saw for splitting the stone, as the sawing disc might bend and deviate from the desired line. After weeks of consideration and preparation, including four days to make the groove into which the steel cleaving knife was to be inserted, the stone was ready to be split. On 10 February 1908, Joseph Asscher, the most skilful cleaver in the firm, clamped the diamond into a specially made holder and struck the cleavage knife with a heavy steel rod. At the first blow the knife broke and the diamond remained intact. A second cleavage knife was fitted and the second blow split the diamond into two pieces. A few days

RIGHT:
Joseph Asscher cleaving the stone.

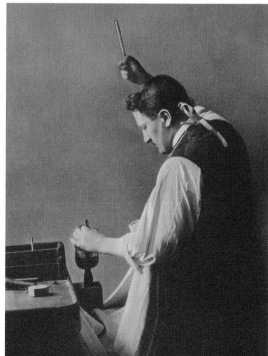

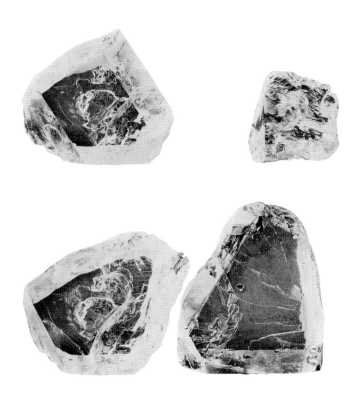

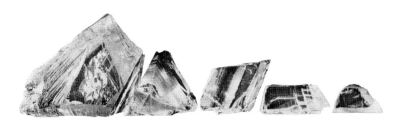

later, the task of dividing the two large pieces into individual stones began. There followed eight months of grinding and polishing, carried out by three polishers working 14 hours a day. Eventually, nine principal numbered stones, 96 small brilliants and nine carats of unpolished fragments resulted from their work. The total weight of the gems cut from the Cullinan amounted to 1,055.9 metric carats, representing a loss of weight through cutting of 65.25 per cent.

On 21 November 1909, the two largest gems, Cullinan I and II, were formally presented to King Edward VII at Windsor Castle. These are the two largest colourless and flawless cut diamonds in the world. They were temporarily mounted as a brooch for Queen Alexandra, but after the king's death in 1910, King George V commanded that Cullinan I, a pear-shaped

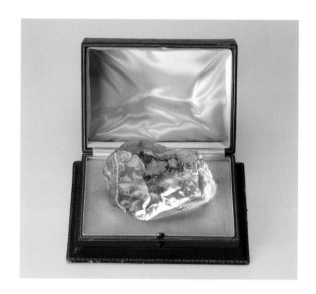

Model of the Cullinan diamond

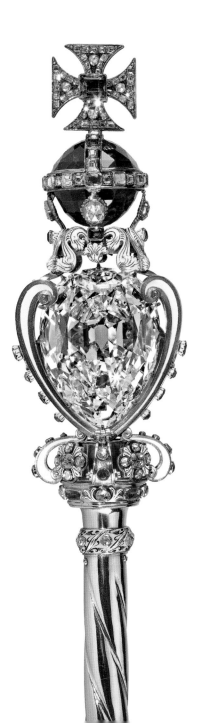

brilliant that weighs 530.2 metric carats and is known as the First Star of Africa, should be set at the head of the Sovereign's Sceptre, part of the Regalia made for Charles II. By the same command, Cullinan II, known as the Second Star of Africa, a cushion-shaped brilliant weighing 317.40 metric carats, was set into the band of the Imperial State Crown. Both stones remain in these positions today, although they are detachable and were occasionally worn as a brooch by Queen Mary.

The head of the Sovereign's Sceptre, 1661, altered in 1911 to incorporate Cullinan I, the First Star of Africa.

CULLINAN III AND IV

1911

The firm of Asscher's retained the numbered stones III–V and VII–IX (King Edward VII having purchased Cullinan VI for Queen Alexandra in 1909; page 70), together with the 96 brilliants and fragments, collectively known as 'the chippings', as payment for their work of cutting and polishing the Cullinan. They were subsequently purchased by the Transvaal government at the insistence of General Botha, with the intention that they should be presented to the Princess of Wales (later Queen Mary) during the visit with the Prince of Wales planned in 1910, to open the first Parliament of the Union of South Africa. The visit was cancelled due to King Edward VII's death, and the stones were presented to Queen Mary in June of that year at Marlborough House, on behalf of the Government and people of South Africa, in memory of the Inauguration of the Union.

FACING:
The Cullinan III and IV brooch, enlarged.

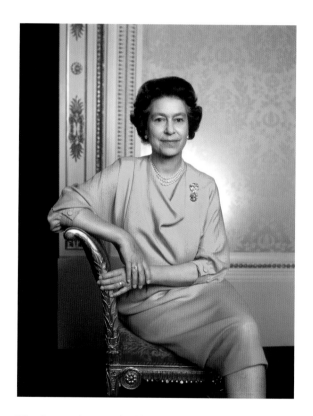

The Queen photographed by Yousuf Karsh (1908–2002) in 1985, wearing the Cullinan III and IV brooch.

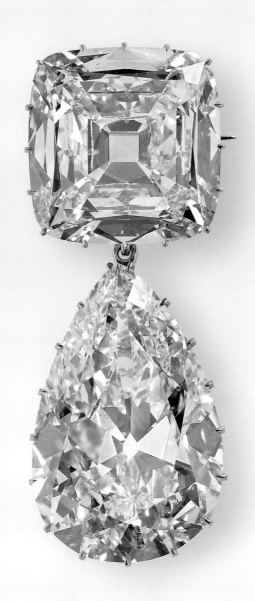

The numbered stones were all mounted by Garrards or Carringtons in 1911 in a variety of settings – brooches, a ring and a necklace. The mounted stones were often worn by Queen Mary in combination, and their settings were designed to be adaptable, allowing many possibilities and combinations for the wearer.

In 1911, Queen Mary had Cullinan III, a pear-shaped drop of 94.4 metric carats, and Cullinan IV, a cushion-shaped stone of 63.6 metric carats, mounted in a lattice-work settings, probably by Carringtons and placed into her new crown made by Garrard for the coronation. The following year the Delhi Durbar Tiara (page 52) was adapted to take both stones. Cullinan III was occasionally used as a pendant to the Coronation Necklace (page 28) in place of the Lahore Diamond, and on at least one occasion Queen Mary wore this necklace with Cullinan I and II as a brooch. However, the stones were most often worn hooked together as a pendant brooch.

In 1953, The Queen inherited the brooch and has worn it regularly throughout her reign, notably in 1958 during her State Visit to Holland, when she toured Asscher's premises.

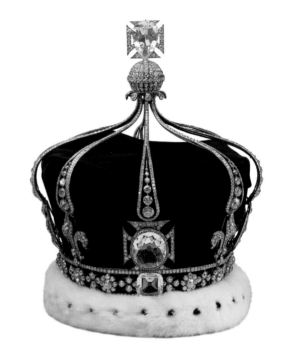

ABOVE:
Queen Mary's Coronation Crown with Cullinan III and IV.

FACING:
W & D Downey, *Queen Mary, The House of Lords*, 6 Feb 1911. Gelatin silver print. Queen Mary is wearing Cullinan I and II on her garter riband and III and IV attached to the Coronation Necklace.

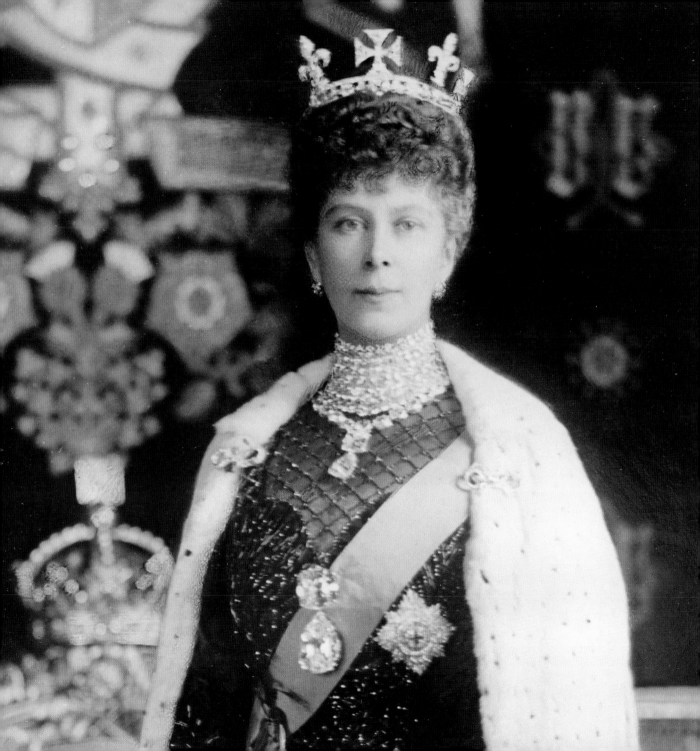

CULLINAN V

1911

This heart-shaped stone weighs 18.8 metric carats and is mounted in a fine radiating platinum web, with a scrolling *millegrain* and pavé-set border of brilliant diamonds. The mounting of the jewel was designed to be as adaptable as possible, so that it could be worn in several different guises. It was most often worn by Queen Mary, and now by The Queen (who inherited it 1953), as a brooch. It forms the detachable centre section of the diamond and emerald stomacher made for Queen Mary for the Delhi Durbar in 1911. It can also be suspended from the Cullinan VIII

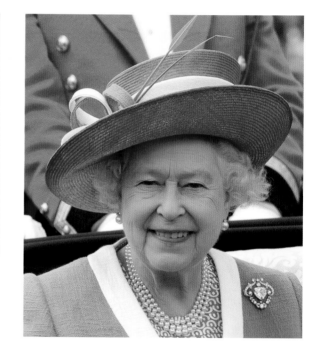

RIGHT:
The Queen wearing the Cullinan V brooch
at Royal Ascot in 2009.

FACING:
The Cullinan V brooch, enlarged.

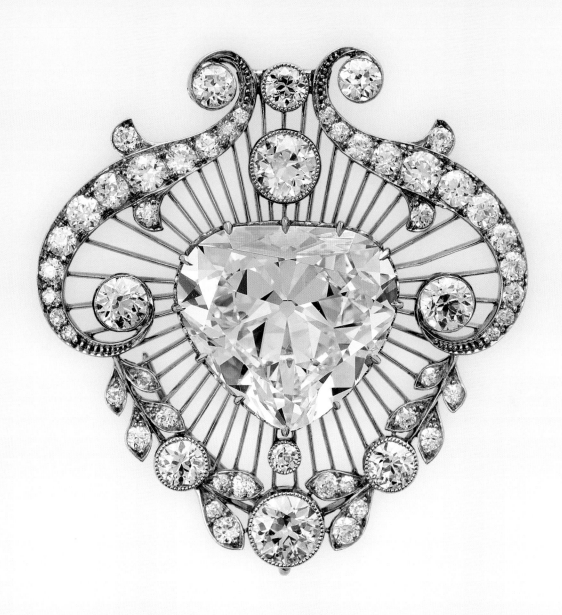

Brooch (page 80) with the Cullinan VII Pendant below (page 82). In 1937, for the coronation of King George VI, Queen Mary wore Cullinan V in her 1911 coronation crown, worn as a coronet (minus its arches), in place of the Koh-i-nûr.

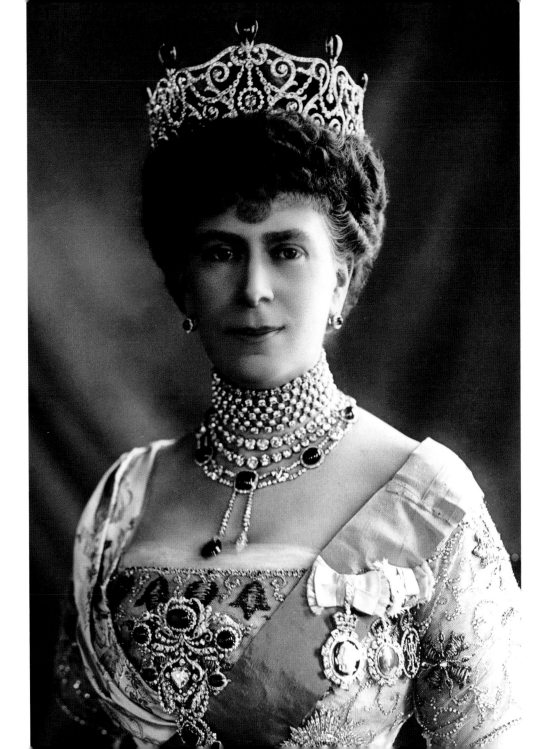

CULLINAN VI AND VIII

1911

The marquise-cut Cullinan VI weighs 11.5 metric carats and was purchased by King Edward VII from Asscher's in 1908 as a gift for Queen Alexandra. It was mounted by Garrard & Co. Ltd in November 1910 into a new circlet, made as a substitute for the Diamond Diadem (page 108), which had passed to Queen Mary on King Edward's death.

In 1911, Garrard set Cullinan VIII, which had been presented to Queen Mary with the five other numbered Cullinan stones, into a fine radiating platinum mount, in the same style as that for Cullinan V. Cullinan VIII is an emerald-cut stone of 6.8 metric carats. Cullinan VI, which was inherited by Queen Mary after Queen Alexandra's death in 1925, was generally worn as the pendant to Cullinan VIII. Cullinan VIII was mounted to be just as adaptable as the other numbered stones, and could be worn as part of the Delhi Durbar stomacher and also linked to the Cullinan V Brooch. Cullinan VI and VIII were inherited by The Queen in 1953.

The Queen, photographed by Terry O'Neill (b. 1938) in 1990, wearing the Cullinan VI and VIII brooch.

FACING:
The Cullinan VI and VIII brooch, enlarged.

80

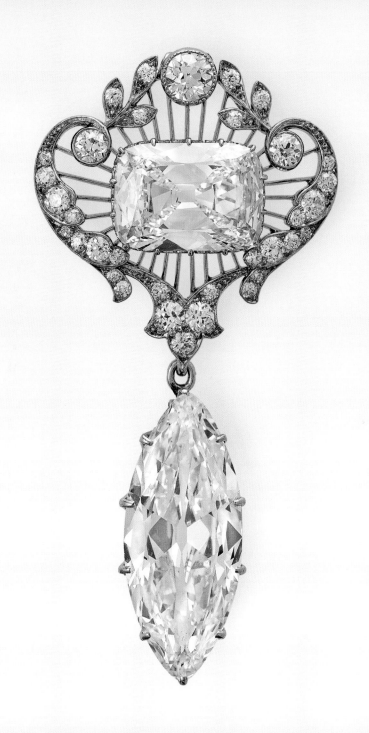

THE DELHI DURBAR NECKLACE AND CULLINAN VII PENDANT

1911

This necklace of diamonds and emeralds set in platinum and gold was one of the principal elements of Queen Mary's parure of diamonds and emeralds created for the Delhi Durbar of 1911. The parure consisted of The Delhi Durbar Tiara (page 52), a stomacher (incorporating Cullinan V and VIII), brooch, earrings and this elegant necklace, which, of all the elements of the parure is of a particularly modern design. King George V paid for the parure as a 44th birthday present for Queen Mary.

Cullinan VII was cut by Asscher's as a marquise of 8.8 carats and is suspended as an asymmetrical pendant on a detachable chain of ten graduated brilliant diamonds, to counterbalance the pear-

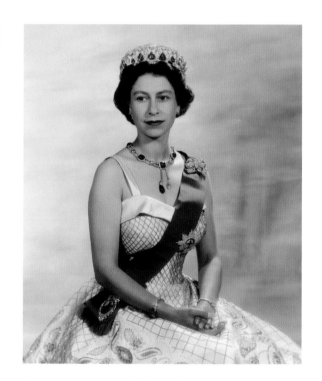

The Queen photographed by Sterling Henry Nahum (1906–56), wearing the Delhi Durbar Necklace, 1956 (RCIN 2081190).

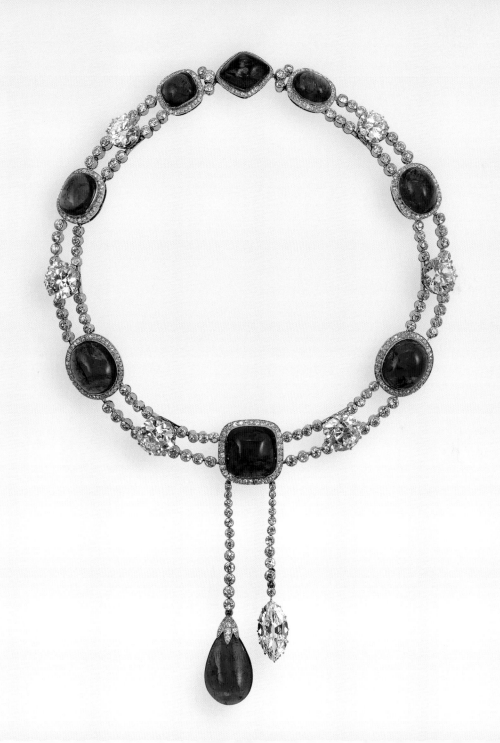

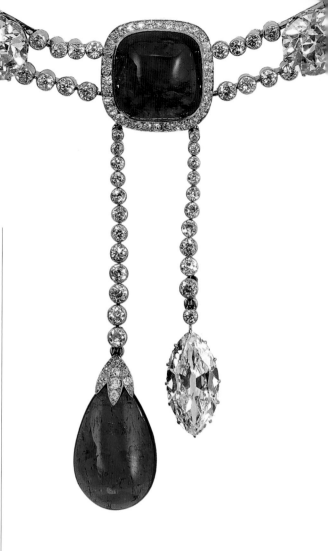

shaped emerald pendant, which is pavé-set and similarly suspended from a detachable, graduated chain of 12 brilliant diamonds. The necklace incorporates nine of the Cambridge emeralds, originally owned by Queen Mary's grandmother, the Duchess of Cambridge. The eight cabochon-cut emeralds are set between six large brilliant diamonds on a double platinum chain, with 94 smaller brilliant-cut diamonds.

The necklace was inherited by The Queen in 1953.

RIGHT:
Detail of Cullinan VII

FACING:
The Queen wearing the Delhi Durbar Necklace, standing with President Nelson Mandela during his State Visit to Buckingham Palace in 1996.

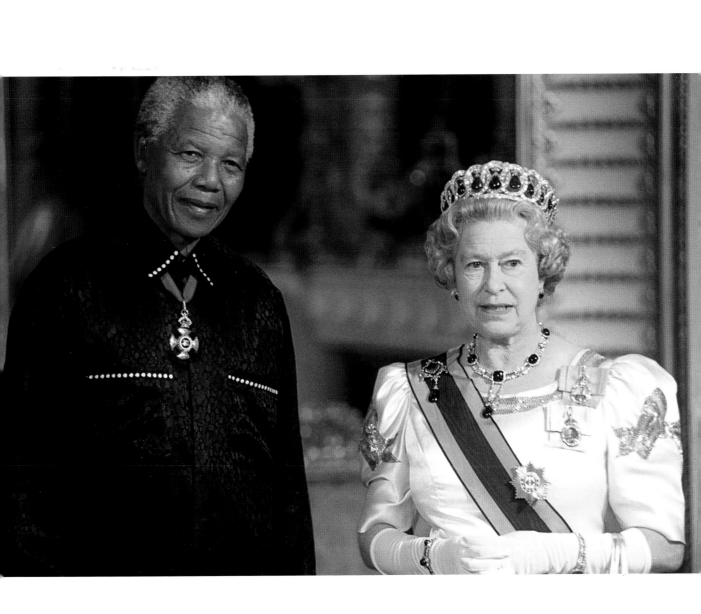

CULLINAN IX

*c.*1911

The smallest of the nine numbered stones is a pear-shaped diamond weighing 4.4 metric carats. It was set into a platinum ring for Queen Mary, probably by Garrard & Co. Ltd in 1911. The pear shape is known as a pendeloque and is mounted in an openwork 12-claw setting. The cutting and polishing of the nine principal stones cleaved from the Cullinan Diamond was a remarkable feat, given the fairly rudimentary equipment available at the time.

THE GREVILLE PEARDROP EARRINGS

1938

In 1942, Mrs Ronald Greville (1863–1942) bequeathed to Queen Elizabeth her spectacular collection of over sixty pieces of jewellery. Mrs Greville, the daughter of the millionaire brewer and philanthropist William McEwan (1827–1913), had married the elder son of the second Baron Greville in 1891 and was a leading society hostess and friend of the royal family. She was widowed in 1908 and had no children. Mrs Greville left her house, Polesden Lacey in Surrey, to the nation. The jewellery collection that she left to Queen Elizabeth contained pieces by the leading firms

RIGHT:
Queen Elizabeth wearing the Greville
Peardrop Earrings, photographed
by Cecil Beaton in 1965.

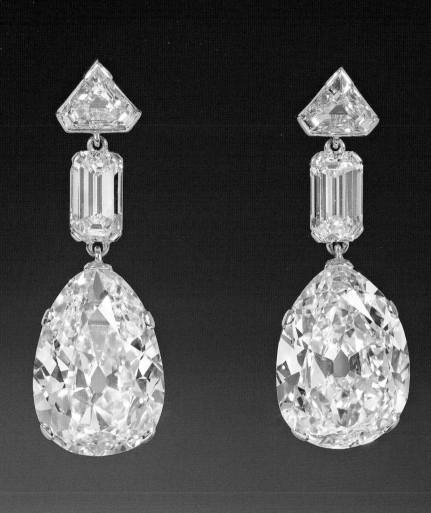

of the day, notably Boucheron and Cartier, the latter being the firm from which Mrs Greville purchased these earrings in 1938. The earrings are formed of pentagonal tops, each suspending an emerald-cut diamond and pear-shaped drop set in platinum. The pear-shaped drops weigh respectively 20.66 and 20.26 metric carats. Queen Elizabeth wore them regularly and they were bequeathed to The Queen in 2002.

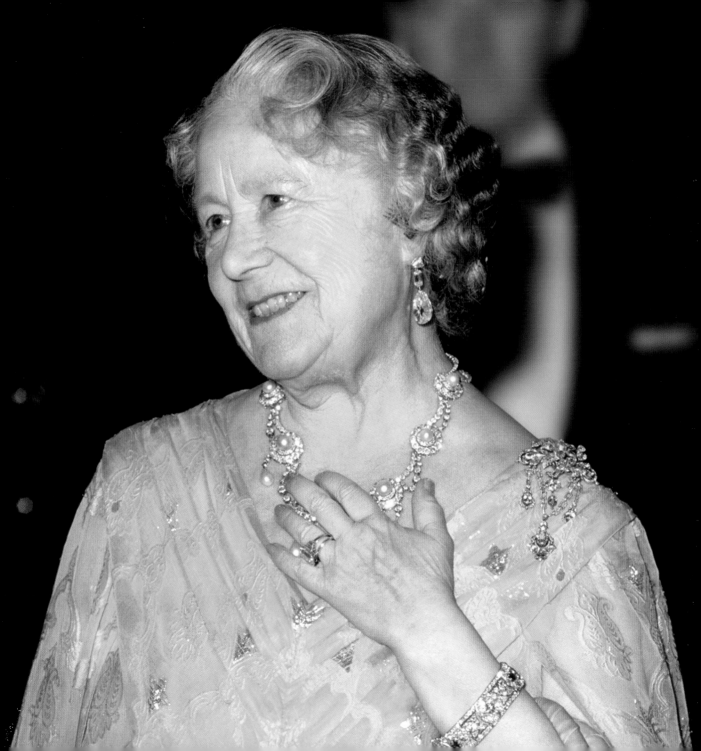

THE GREVILLE CHANDELIER EARRINGS

1929

These strikingly modern earrings were made by Cartier into their present form in February 1929 to the order of Mrs Greville, who bequeathed them to Queen Elizabeth in 1942. Each earring consists of 16 stones, which serve as a lexicon of modern diamond cuts, incorporating pear-shaped drops, half-moon, trapeze, square, baguette, baton and emerald-cut stones. The earrings appear to have been altered from existing ones ordered from Cartier in 1918, to which further additions were made in 1922. Queen Elizabeth bequeathed the earrings to The Queen, who wore them regularly in the 1950s and 1960s.

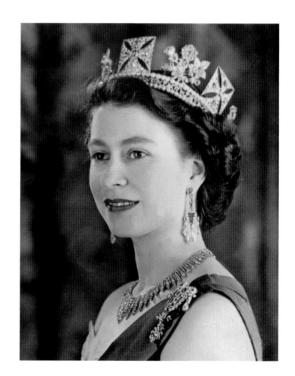

The Queen photographed by Baron in 1953 wearing the Greville Chandelier Earrings along with the Diamond Diadem.

FOLLOWING PAGE:
The Queen wearing the Greville Chandelier Earrings at a dinner in Toronto, Canada, 5 July 2010.

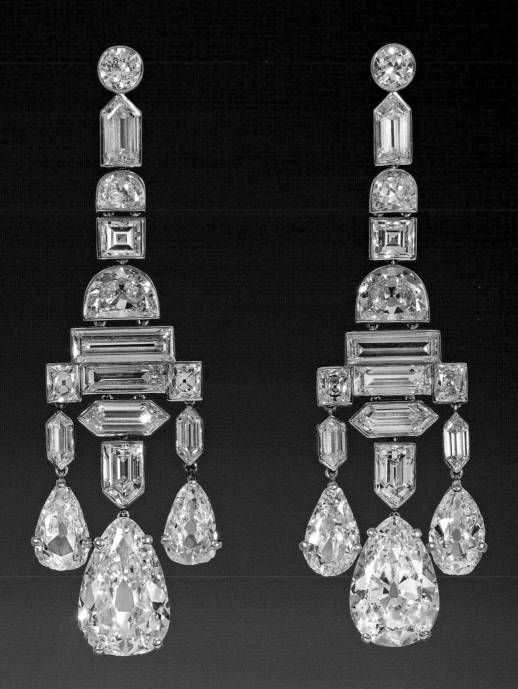

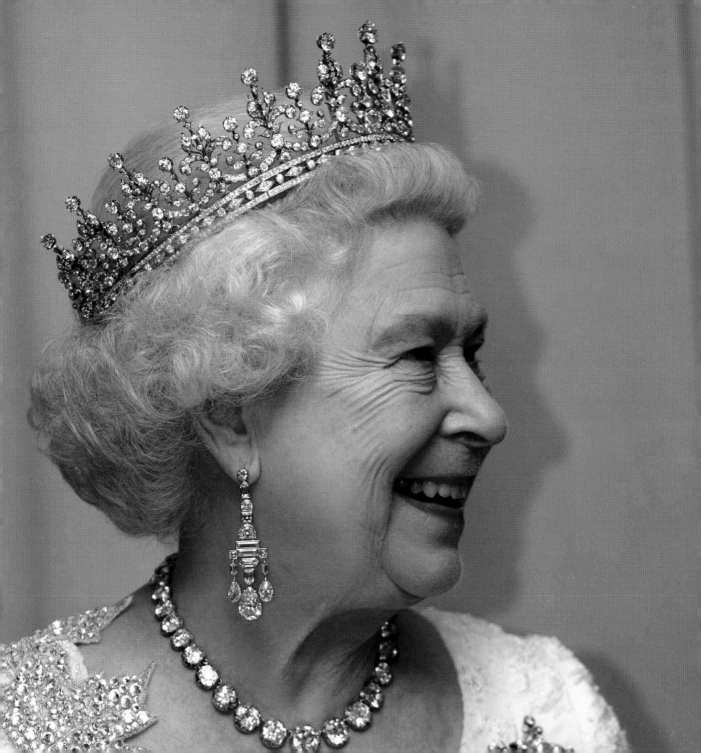

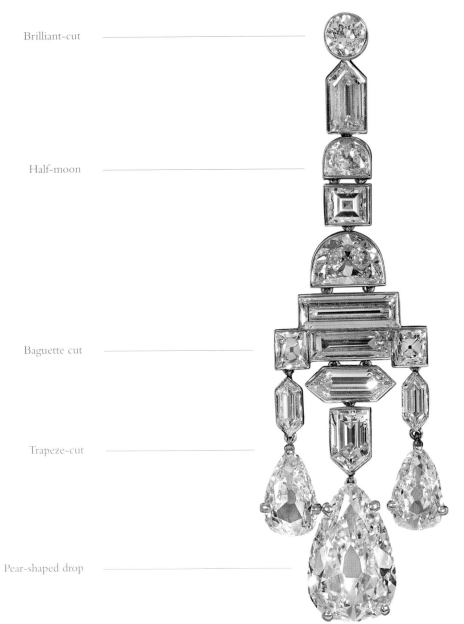

Brilliant-cut

Half-moon

Baguette cut

Trapeze-cut

Pear-shaped drop

THE QUEEN'S SOUTH AFRICA NECKLACE AND BRACELET

1947 and 1952

The 21st birthday of Princess Elizabeth, on 21 April 1947, fell during the South African Tour undertaken by her parents King George VI and Queen Elizabeth, from February to April in that year. The necklace was a present from the Government of the Union of South Africa, given by Field-Marshal Smuts at the culmination of a ball held in Government House, Cape Town. It originally consisted of a long chain of 21 graduated brilliants, the largest of 10 carats, each linked by a baguette-cut diamond and two small brilliant-cut diamonds. The detachable snap-piece of the necklace was added afterwards, using a single 6-carat stone given to the Princess by Sir Ernest Oppenheimer,

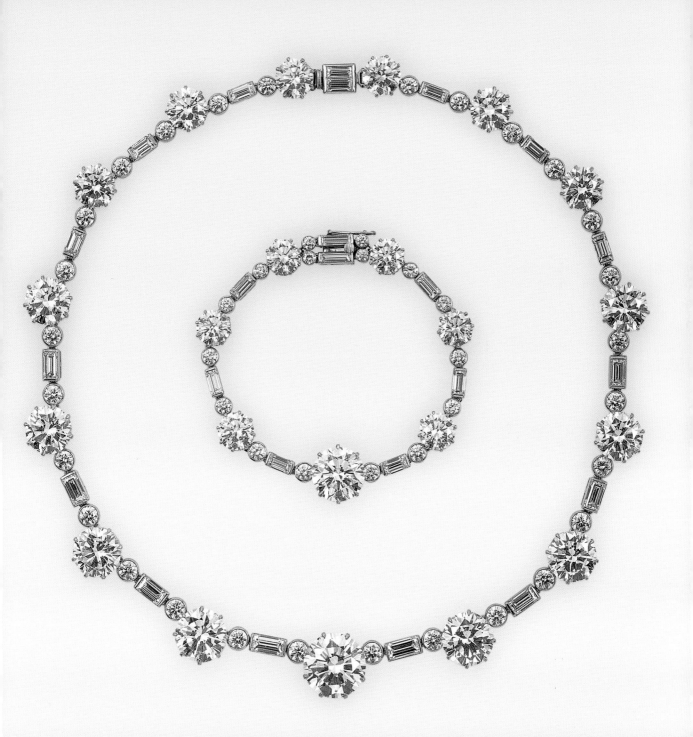

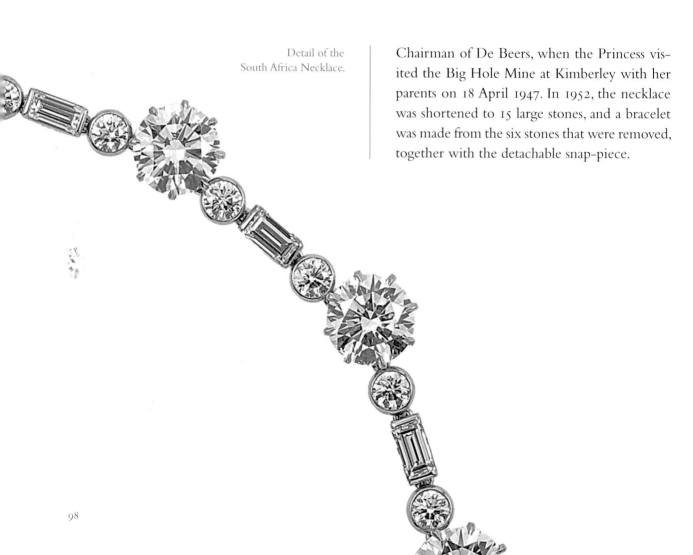

Detail of the
South Africa Necklace.

Chairman of De Beers, when the Princess visited the Big Hole Mine at Kimberley with her parents on 18 April 1947. In 1952, the necklace was shortened to 15 large stones, and a bracelet was made from the six stones that were removed, together with the detachable snap-piece.

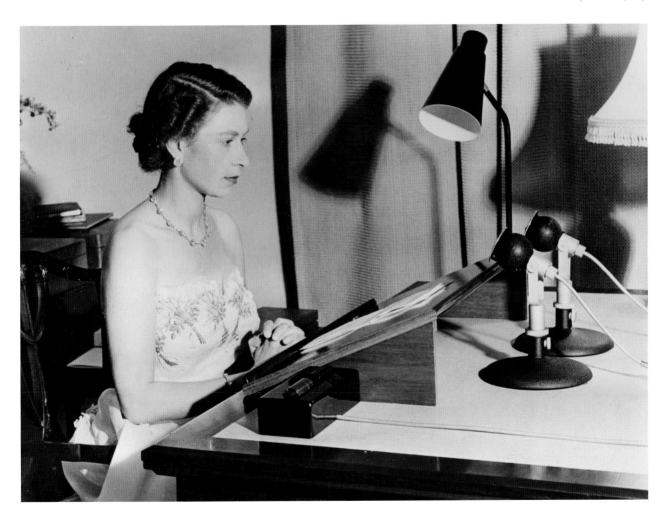

The Queen reading an address, *c.*1957, wearing the South Africa Necklace (RCIN 2004811).

THE QUEEN'S WILLIAMSON DIAMOND BROOCH

1953

The Williamson Diamond is considered the finest pink diamond ever discovered. It was found in October 1947 at the Mwadui mine in Tanganyika, owned by the Canadian geologist and royalist Dr John Thorburn Williamson (1907–58), after whom the diamond was named. The uncut stone, weighing 54.5 metric carats, was presented by Dr Williamson, as a wedding present to Princess Elizabeth in 1947. The stone was cut by the firm of Briefel and Lemer of Clerkenwell into a 23.6-carat round brilliant, maximising its luxurious rose colour. Queen Mary and Princess Elizabeth inspected the work of cutting and polishing during a visit to the Clerkenwell premises on 10 March 1948. When

RIGHT:
Detail of The Queen's Williamson
Diamond Brooch.

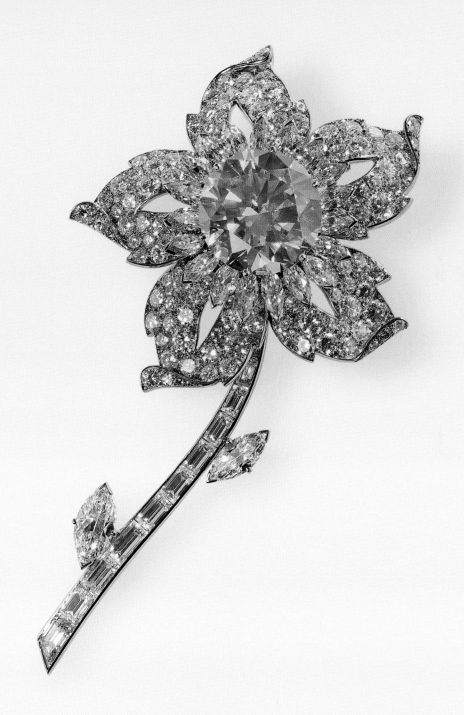

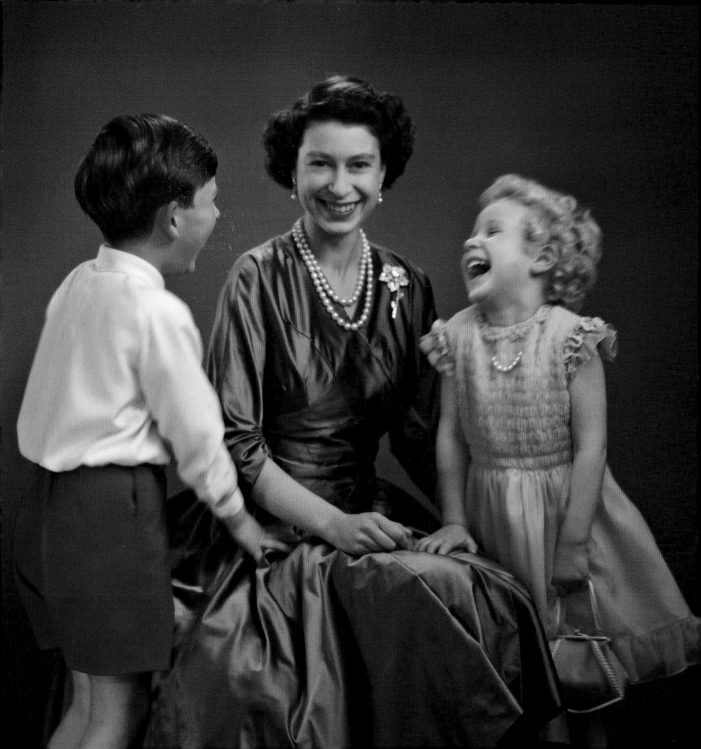

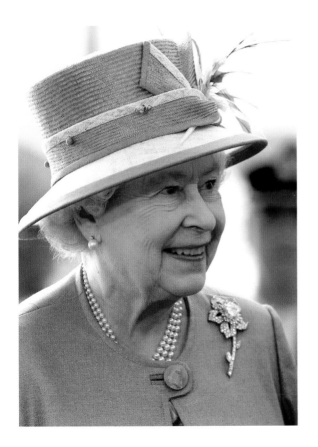

the Queen acceded to the throne in 1952, there was speculation that the stone might be mounted for use at the coronation. However, it was instead set as the centre of a brooch in the form of a jonquil flower, designed by Frederick Mew of Cartier, in 1953. Dr Williamson wished to add further pink diamonds to his original gift, but as these were not available, he gave The Queen 170 small brilliant-cut diamonds, 12 baguette-cut diamonds and 21 marquise diamonds, which were incorporated into this brooch to form the petals, the stalk and the leaves.

LEFT:
The Queen wearing the Williamson Diamond Brooch in Winnepeg, Canada, on 3 July 2010.

FACING:
Marcus Adams (1875–1959), *HM Queen Elizabeth II, Prince Charles and Princess Anne*, 6 November 1954 (RCIN 2943738).

GEORGE IV'S DIAMOND-HILTED SWORD

*c.*1750 and 1820

The boatshell hilt of this small-sword dates from about 1750 and was probably made in Germany, but it was altered in 1820, the year of accession of George IV, by the royal goldsmiths and jewellers Rundell, Bridge & Rundell.

George IV's sophisticated artistic taste and extravagance are well documented. He commissioned lavish building schemes at Carlton House, Brighton Pavilion, Buckingham Palace and Windsor Castle, heralding one of the most significant periods of acquisition in the history of the Royal Collection. He was a prolific purchaser of jewels, including this sword, which cost the very considerable sum of £3,687. The hilt is mounted with hundreds of brilliant and rose-cut diamonds in rub-over gold settings applied to gold, which is richly chased with rococo ornament. The diamond ornament, blade and scabbard all appear to have been produced by Rundell, who added to the existing diamond

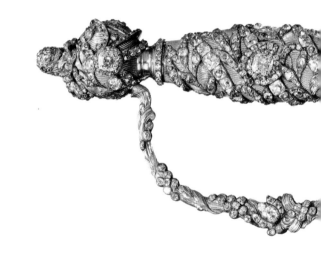

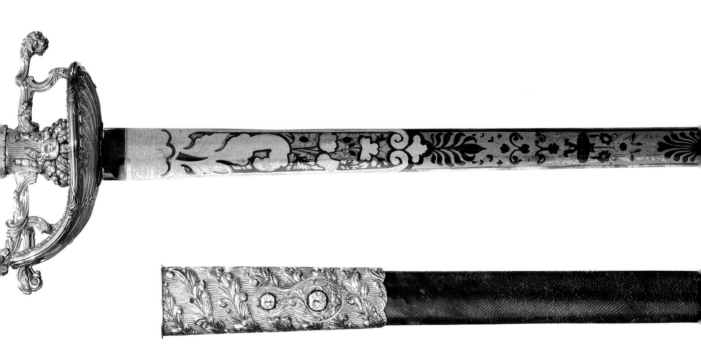

embellishment of the sword. They submitted a bill dated 7 August 1820, which refers to 'mounting a large diamond & chased Gold Sword, with diamond Shell Helmet richly set with Brilliants all over the Hilt'. The pommel is in the form of a barred helmet with a lion couchant as a crest, and the forward cross-guard is also fashioned into a lion's head. Rundell's bill records that '2 very large Brilliants' were added to the sides of the grip and '31 large do [diamonds]. Added to the Gripe & border of Shell & 772 fine smaller do.', together with a further 439 rose diamonds.

The two-edged blade is richly etched and gilded with foliage and military trophies and the royal monogrammed crown on a blued ground, and is strikingly similar to the blade of the Sword of Offering, which the King commissioned from Rundell a year later for his coronation. The wooden scabbard covered in black fish skin is set with gold mounts chased with acanthus leaves and set with further brilliant diamonds.

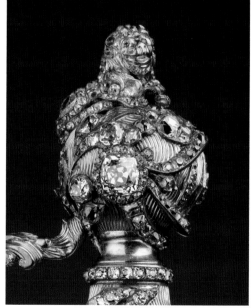

RIGHT:
Details of diamond setting and of the pommel showing the helmet surmounted by a lion couchant.

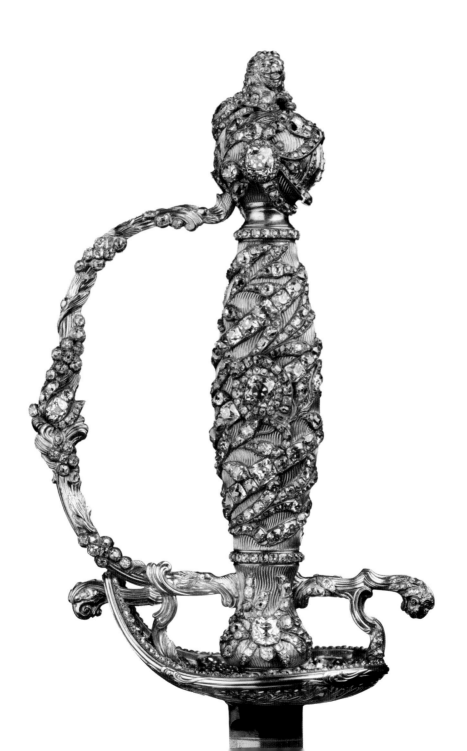

This diamond and pearl circlet or diadem was made for the coronation of George IV and probably designed by Philip Liebart, chief designer and diamond-setter at the firm of Rundell, Bridge & Rundell, who also designed the King's coronation crown. The diadem was intended to be worn by the King in procession from Westminster Hall to the Abbey on coronation day, and was to sit over his large velvet 'Spanish' hat or Cap of State. Contemporary accounts and depictions of the coronation show that the diadem was, in the event, barely visible over the velvet and plumed hat.

The diadem consists of a band set with two rows of pearls either side of a row of brilliant-cut diamonds, above which, entirely of brilliant-cut diamonds in the new style of transparent setting, are four slightly convex crosses-paty, set between four patriotic devices combining a rose, a thistle and two shamrocks – the combined national

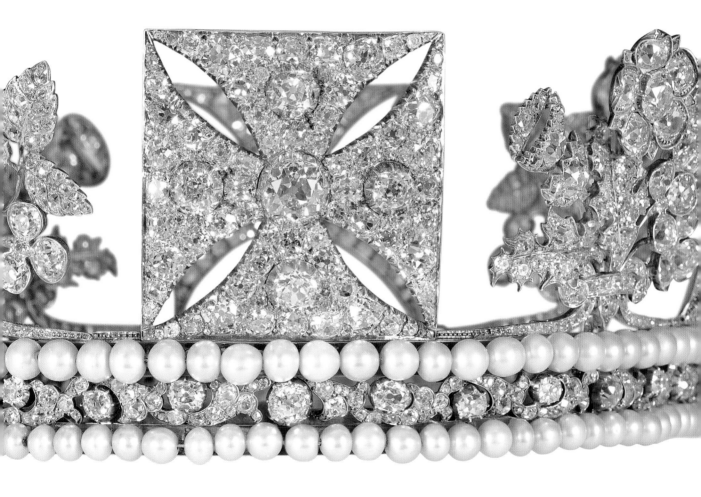

emblems of England, Scotland and Ireland. This new device recalled the Act of Union of 1800, which had created the United Kingdom of Great Britain and Ireland, but it also reflected the King's wish to exclude the more traditional fleur-de-lis motif from the English regalia. The 169 pearls and 1,333 diamonds are set into an openwork silver frame lined with gold. The most striking diamond in the circlet is the 4-carat pale yellow brilliant in the centre of the front cross-paty. The bill for the diadem, dated 6 May 1820, records a cost of £290 for setting the jewel and £800 for the loan of the diamonds. It was usual at this date for diamonds to be hired for coronations, and the figure of £800 represents roughly 10 per cent of their value at that time.

George IV's coronation was planned for the summer of 1820, but had to be postponed due to the return to England of his estranged wife,

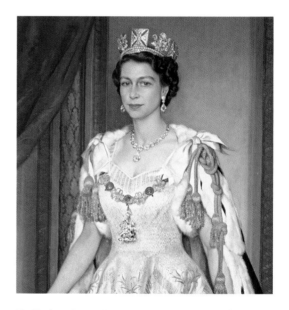

Sir Herbert James Gunn (1893-1964), *Queen Elizabeth II in Coronation Robes*, 1953-4. Oil on canvas (RCIN 164532).

RIGHT:
Antony Armstrong-Jones (b. 1893),
HM Queen Elizabeth II, 1957.

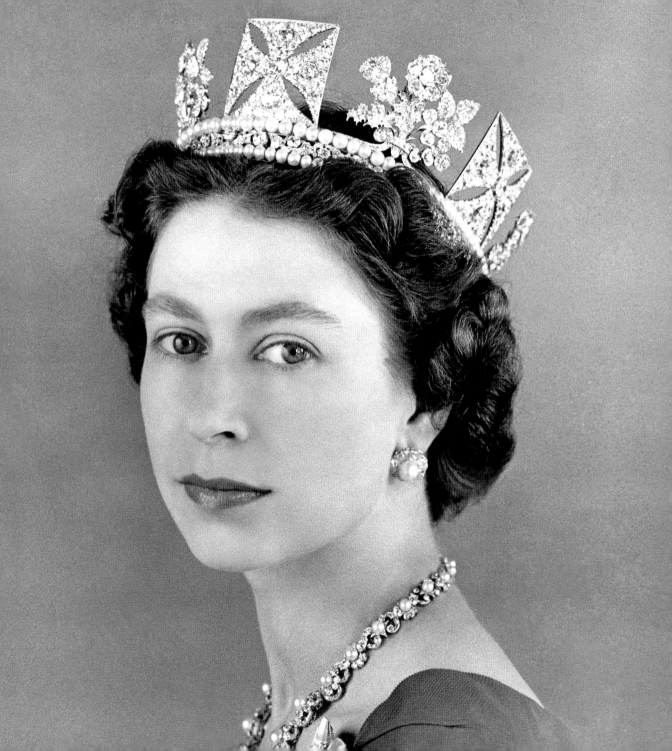

Queen Caroline, and her ensuing trial. The coronation finally took place on 19 July 1821, after which the diadem was retained, the King having settled a bill for a little over £8,000. In the next reign it was worn regularly by Queen Adelaide, consort of William IV, who established the tradition of feminine use for the diadem. In 1837, it was inherited by Queen Victoria. who was frequently painted and photographed wearing the diadem. She also appears wearing it on several early postage stamps, including the penny black. The diadem passed via Queen Alexandra, Queen Mary and Queen Elizabeth to Her Majesty The Queen, who memorably wore it on the way to Westminster Abbey for her coronation in June 1953. It has been worn on the journey to and from every State Opening of Parliament in this reign since the first, which took place on 4 November 1952.

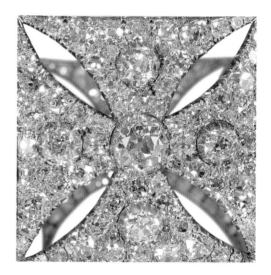

Detail of the Diamond Diadem showing the yellow diamond set in the central cross paty.

FACING:
The Queen wearing the Diamond Diadem at the State Opening of Parliament, 3 December 2008.

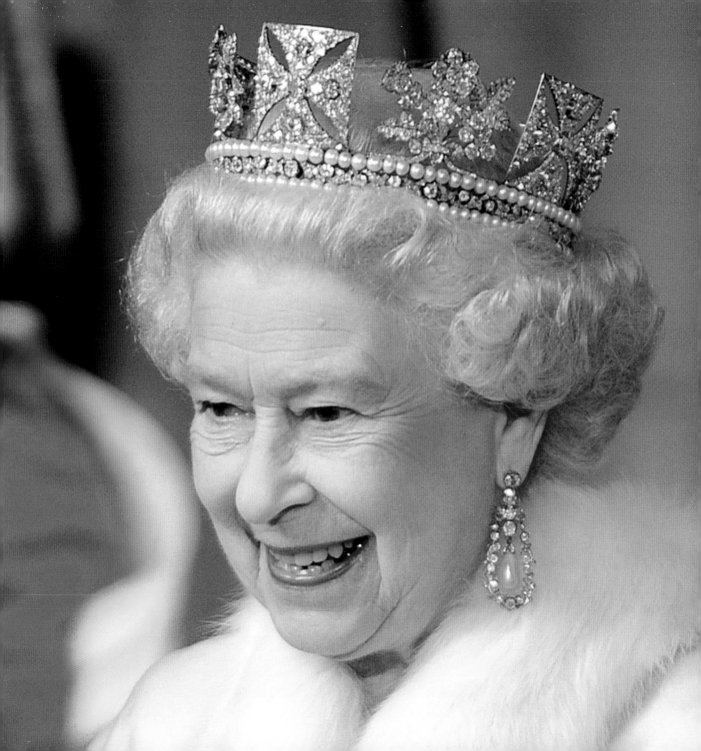

GLOSSARY

Baguette:	Long narrow rectangular cut with flat top; used interchangeably with 'baton' and 'stick'.
Brilliant (modern):	Diamonds (usually circular) with 58 facets, cut in a pattern perfected around 1920.
Brilliant (old cut):	Diamonds with a flat top or table, in a variety of shapes, sometimes almost square, and without the mathematically precise faceting of the modern brilliant-cut diamond (the standard cut for most nineteenth- and early twentieth-century jewellery).
Chaîne de corsage:	Jewelled decoration worn along the edge of the bodice of a dress.
Cleavage face:	The plane along which a gem has been split.
Cleavage knife:	Specialist tool placed on a diamond which when tapped with a hammer splits it in the desired place.
Cross-guard:	The bar between the grip and blade of a sword to protect the hand.
Cross-paty:	A cross with arms of equal length expanding outwards from the centre.
Diadem:	A form of princely headdress, usually without arches.

Emerald cut:	Rectangular stone with chamfered corners (that is, octagonal in outline), faceted sloping sides and flat top or table.
Fleur-de-lis:	A three-leaf floral emblem, found on English crowns.
Grip:	The handle of a sword.
Half-moon:	One half of a round brilliant-cut stone with a straight side.
Monde:	A small metal or jewelled ball, often representing the world, found on top of crowns.
Parure:	A suite of matching jewellery.
Peardrop:	A traditional variety of fancy brilliant-cut diamond of pear shape.
Pommel:	Knob at the end of the grip of a sword acting as a counter-weight to the blade.
Rose:	A diamond with 24 facets and flat base rising to a point; a style of cutting generally reserved for smaller stones.
Trapeze:	A step-cut or emerald-cut stone in trapezoid form.

The Size of Brillant Diamonds.

Number	Weight	Number	Weight	Number	Weight
1	1	13	$3\frac{3}{4}$	22	7
2	$1\frac{1}{8}$	14	4	23	$7\frac{1}{2}$
3	$1\frac{1}{4}$	15	$4\frac{1}{4}$	24	8
4	$1\frac{1}{2}$	16	$4\frac{1}{2}$	25	9
5	$1\frac{3}{4}$	17	$4\frac{3}{4}$	26	10
6	2	18	5	27	11
7	$2\frac{1}{4}$	19	$5\frac{1}{2}$	28	$12\frac{1}{2}$
8	$2\frac{1}{2}$	20	6		
9	$2\frac{3}{4}$	21	$6\frac{1}{2}$		
10	3				
11	$3\frac{1}{4}$				
12	$3\frac{1}{2}$				

LEFT:

'Table of Brilliant Cut diamonds,' from
*A Treatise on diamonds and pearls in which
their importance is considered and plain rules are
exhibited for ascertaining the value of both: and
the true method of manufacturing diamonds*,
David Jeffries, 1751.

FACING:

'Table of Rose Cut diamonds,' from
*A Treatise on diamonds and pearls in which
their importance is considered and plain rules are
exhibited for ascertaining the value of both: and
the true method of manufacturing diamonds*,
David Jeffries, 1751.

The Sizes of Rose Diamonds.

Number	Weight	Number	Weight	Number	Weight
1	1	13	$3\frac{3}{4}$	22	7
2	$1\frac{1}{8}$	14	4	23	$7\frac{1}{2}$
3	$1\frac{1}{4}$	15	$4\frac{1}{4}$	24	8
4	$1\frac{1}{2}$	16	$4\frac{1}{2}$	25	9
5	$1\frac{3}{4}$	17	$4\frac{3}{4}$	26	10
6	2	18	5	27	11
7	$2\frac{1}{4}$	19	$5\frac{1}{2}$	28	$12\frac{1}{2}$
8	$2\frac{1}{2}$	20	6		
9	$2\frac{3}{4}$	21	$6\frac{1}{2}$		
10	3				
11	$3\frac{1}{4}$				
12	$3\frac{1}{2}$				

BIBLIOGRAPHY

Balfour 2009	I. Balfour, *Famous Diamonds*, Woodbridge
Blair 1998	C. Blair (ed.), *The Crown Jewels. The History of the Coronation Regalia in the Jewel House of the Tower of London*, London
Bury 1991	S. Bury, *Jewellery 1789–1910*, 2 vols, Woodbridge
Collins 1955	A.J. Collins, *Jewels and Plate of Queen Elizabeth I*, London
Cunningham 2011	D. Cunningham, *The Diamond Compendium*, London
Gere and Rudoe 2010	C. Gere and J. Rudoe, *Jewellery in the Age of Queen Victoria. A Mirror to the World*, London
Keay 2011	A. Keay, *The Crown Jewels*, London
Munn 2001	G.C. Munn, *Tiaras. A History of Splendour*, London
Roberts 2012	H. Roberts, *The Queen's Diamonds*, London
Rudoe 2005	J. Rudoe, *Queen Charlotte's Jewellery: Reconstructing a Lost Collection, in the Wisdom of George the Third*, London
Scarisbrick 1994	D. Scarisbrick, *Jewellery in Britain 1066–1837*, London
Scarisbrick 1995	D. Scarisbrick, *Tudor and Jacobean Jewellery*, London
Scarisbrick, Vachaudez and Walgrave 2008	D. Scarisbrick, C. Vachaudez and J. Walgrave (eds), *Brilliant Jewels from European Courts*, Brussels
Tolansky 1962	S. Tolansky, *The History and Use of Diamond*, London

ACKNOWLEDGEMENTS

In the preparation of this book I am indebted to the following colleagues: Dominic Brown, Nina Chang, Stephen Chapman, Christopher Cavey, Jacky Colliss Harvey, Katie Holyoak, Karen Lawson, Jonathan Marsden, Simon Metcalf, Stephen Murray, Hugh Roberts, Melanie Wilson.

PICTURE CREDITS

Written by Caroline de Guitaut

Published by Royal Collection Trust / © HM Queen Elizabeth II 2012.

Reprinted 2012

ISBN 978 1 905686 42 1

SKU 014238

British Library Cataloguing in Publication Data:

A catalogue record of this book is available from the British Library.

Designed by: Paul Sloman

Production by: Debbie Wayment

Colour reproduction by: Altaimage, London

Printed and bound by: Graphicom srl, Vicenza, Italy

Printed on: Gardamatt 150gsm